Sunken Plantations

THE SANTEE COOPER PROJECT

Douglas W. Bostick

Charleston · London

THE
History
PRESS

Published by The History Press
Charleston, SC 29403
www.historypress.net

Cover design by Marshall Hudson.
All images courtesy of Santee Cooper unless otherwise noted.

First published 2008
Second printing 2010

Manufactured in the United States

ISBN 978.1.59629.469.1

Library of Congress Cataloging-in-Publication Data

Bostick, Douglas W.
Sunken plantations : the Santee Cooper project / Douglas W. Bostick.
p. cm.
Includes bibliographical references.
ISBN 978-1-59629-469-1
1. Plantations--South Carolina--History. 2. Plantations--South Carolina--History--Pictorial works. 3. Historic
sites--South Carolina. 4. Historic sites--South Carolina--Pictorial works. 5. Berkeley County (S.C.)--History,
Local. 6. Orangeburg County (S.C.)--History, Local. 7. Berkeley County (S.C.)--History, Local--Pictorial works.
8. Orangeburg County (S.C.)--History, Local--Pictorial works. 9. Santee Canal (S.C.)--History. 10. South
Carolina Public Service Authority--History. I. Title.
F270.B67 2008
975.70022'2--dc22
2008006554

*This book is dedicated to the ladies of the Pinopolis Book Club,
established in 1935, in admiration for their contributions to the Lowcountry
and their efforts to keep telling the stories of our history. Only if the day
arrives, when one generation fails to pass off great stories to the next,
will the spirit of our forebears die.*

CONTENTS

Contents

ACKNOWLEDGEMENTS

Raised on James Island, South Carolina, I developed an early interest in South Carolina history through my grandfather, who owned a water well drilling company. I began working with him on Saturdays and summer break as soon as I was old enough to push a shovel into dirt.

His business travels took us both all over the Lowcountry and he entranced me with tales of South Carolina history, including the lost plantations in Berkeley and Orangeburg Counties. I've boated and fished in Lake Marion and Lake Moultrie, daydreaming about the stories now buried under the muddy waters.

Sunken Plantations tells this story through the captivating photographs and drawings of the Santee Cooper Project and the great plantations lost to the flood. As Leize Palmer Gaillard, a descendant of St. John's planters, aptly pointed out, progress can be an insatiable monster. The loss of these historic sites and the disruption to our communities and families needs to be recognized. However, we also need to recognize and celebrate the innumerable advantages the Santee Cooper Project has, and is still, providing to South Carolina.

As with any book, this work would not be possible without the willing assistance of many. The staffs of the South Carolina Historical Society, the Charleston Library Society and the South Carolina Room of the Charleston County Public Library and their historic resources are always invaluable. Thank you to the staff and resources of the Library of Congress. Though this is the first time I've searched their collection, the collection of the former Farm Security Administration is an incredible resource.

Thank you to the office of the Senate curator and the U.S. Senate Commission on Art for their permission to use the paintings of the great South Carolina painter John Blake White.

I am indebted to Wendy Dennis and the staff of Records Management at Santee Cooper. They patiently allowed my intrusion in their busy schedules, but eagerly assisted in my search through their archives. Thank you too to Williard Strong at Santee Cooper, a great resource for Berkeley County history.

In my travels as a writer and historian, I meet many interesting and fascinating people. This project led me to Sarah Spruill in Cheraw, South Carolina, a descendant of the Cain family

of St. John's Parish. A more gracious and charming Southern woman you'll never meet. She was of great help, providing her family photographs and tales of St. John's.

Thank you to my good friends, Helen Schiller and Roulain Deveaux, granddaughters of Charleston photographer George W. Johnson, for their permission to use his pictures. Johnson, the founder of the Charleston Camera Club, carefully used his camera to record life in the Lowcountry from 1880 to 1920. His images of African American life are treasures to appreciate.

I am indebted to my good friend and fellow writer Anne Sinkler Whaley LeClercq. She quickly offered her images of Belvidere Plantation and the Sinkler family. I commend her three books on the Sinkler family to your attention, and fortunately she has more treasures to come.

Thank you to Magan Lyons and the staff at The History Press. Magan's encouragement, vision and advice brought this project to completion.

Finally, a big thanks to my wife Karen and my children, Katey, Brooks and Taylor. Their understanding and enthusiastic support allows me to follow and write about these great stories of South Carolina and the Lowcountry.

The Story

By the mid-eighteenth century, South Carolinians desired a waterway route from the midstate to the Charleston ports. Rivers and creeks served as the highways of early America, providing quicker and easier routes than cutting through the frontier. This desire to effectively connect the state led to the Santee Canal project in 1793. In the early twentieth century, renewed interest in a waterway route and the need for hydroelectric power fueled the drive that led to the Santee Cooper Project.

This book records those two efforts and the price we pay for progress.

THE OLD SANTEE CANAL

As early as 1770, a committee of the Commons House of Assembly discussed the need to connect the Santee and Cooper Rivers. Such a project would, for the first time, allow products and raw goods from the midstate to efficiently reach the port of Charleston. Likewise, foodstuffs and finished goods could easily ship from Charleston to these newer settlements.

The assembly hired an engineer, Henry Mouzon, to survey the possible routes for such a connection. By 1775, Mouzon reported on five routes to connect the rivers. Unfortunately, the advent of the Revolutionary War diverted everyone's attention from the project.

In January 1782, with the British still occupying Charleston, the South Carolina General Assembly met in Jacksonborough on the Edisto River. The assembly approved a commission to "cause the land between the Santee and Cooper Rivers, to be surveyed and examined and to fix on the most convenient place for cutting a canal so as to open a navigation route from one to the other of these rivers." The assembly was pleased with this first bold step, but lacked the necessary funds to follow through.

In November 1785, a group of Charleston citizens petitioned the state assembly for a charter to pursue the canal plan. In early 1786, the South Carolina General Assembly chartered a "company for the inland navigation between the Santee and Cooper Rivers." General William Moultrie was appointed president; John Rutledge, former governor and president of the Republic of South Carolina, was vice-president; and Generals Francis Marion and Thomas Sumter were selected as directors.

Moultrie wrote to George Washington seeking advice as to the selection of an engineer for this venture. Washington responded that he thought the most talented engineers were French. Despite the advice, the commission hired a Swedish engineer, Colonel John Christian Senf, who had served with Sumter in the war.

Senf insisted on finding his own route to build the canal rather than selecting one of the options identified by Mouzon. Senf's choice of route ignored the natural water routes through the region, an important problem with his plan.

Work did not begin until 1793, due to a critical labor shortage. Planters were busy shifting their crops from indigo to cotton and were not anxious to make their slaves available for the

project. White laborers shied away from volunteering to work in the swamps in the summer due to the heat and the danger of fevers.

Eventually, the project hired as many as one thousand laborers to build the canal using picks, shovels and wheelbarrows. Finally, the Santee Canal was complete in 1800 at a cost of $750,000. The canal was thirty-five feet wide at the surface, twenty feet wide at the bottom and five and a half feet deep. Workers also constructed a ten-foot-wide towpath to allow draft animals to pull boats.

In May 1801, William Buford traveled the ninety-mile trip above Columbia on the Broad River to arrive in Charleston using the new Santee Canal. Everyone asserted this canal would create great wealth for the state. Unfortunately, Senf's choice of routes had a fatal flaw and seasonal droughts would sometimes dry up sections of the canal. The canal also began to compete with the railway, which was now extending to the mid- and upstate.

The canal company charged every boat a flat fee, regardless of whether was empty or loaded. The freight companies creatively responded by building boats that could be stacked on the return trips. This loss of fees deeply affected the canal company.

Eventually, the railway, both faster and more dependable, out competed the Santee Canal. By the 1840s, the canal was slipping into disuse. In 1850, the General Assembly revoked the charter for the canal company.

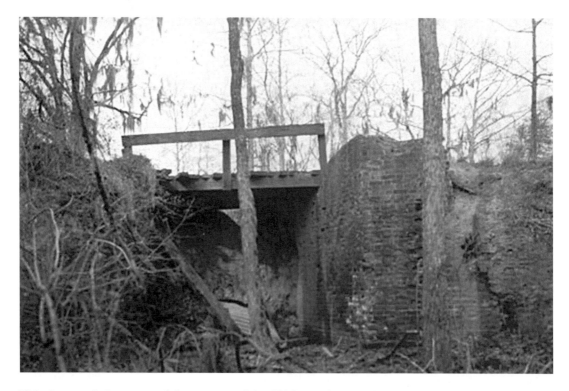

This photograph shows some of the remnants of the Old Santee Canal, which stretched from White Oak Landing on the Santee River to Biggin Creek on the Cooper River.

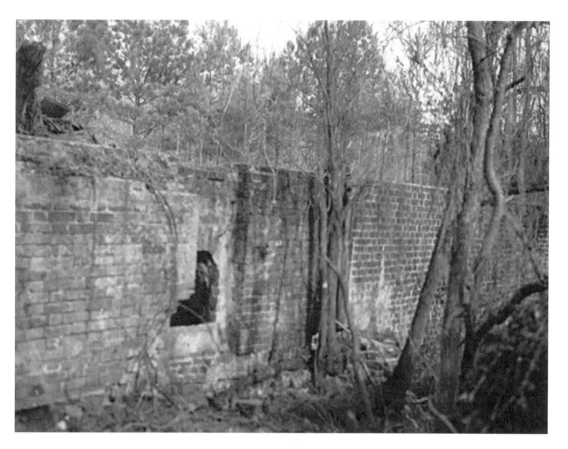

The canal had three sections: the first ascended thirty-four feet in two and a half miles; the second was level for five miles; and the third descended sixty-nine feet in fourteen and a half miles to the Cooper River.

THE SANTEE COOPER PROJECT

In 1913, the Columbia Railway and Navigation Company was running steamship service from Columbia to Georgetown. They filed a request to amend its charter to construct a more suitable navigation route between the Santee and Cooper Rivers. Though approved, the company lacked funding to immediately pursue the plan.

By 1917, the Charleston Chamber of Commerce was clamoring for a canal, both for navigation and electricity generation. In 1923, Charleston Mayor John Grace wrote Colleton County State Senator J.P. Padgett of his desire for a hydroelectric project using the Santee and Cooper Rivers. Grace asserted that the project would "transform Charleston," providing a much-needed boost to an economically depressed region.

Gabriel A. Guignard and T.C. Williams, Columbia businessmen and partners in the Columbia Railway and Navigation Company, seized on the opportunity and new-found interest. They selected one of the original routes mapped by Mouzon, from Ferguson on the Santee to Moncks Corner on the Cooper. They applied for approval with the Federal Power Commission for both the canal and a power-generating plant at Moncks Corner. In 1926, they were granted a fifty-year license for the project.

South Carolina was already in the midst of an economic depression. The rice industry had given way to stronger competition in Texas and Louisiana. Boll weevils devasted cotton and the market further collapsed after World War I. The stock market crash of 1929 simply added to the trouble of a state already good at being poor. One South Carolina newspaper reported, "In almost every form of human progress, South Carolina has sunk about as far as a state can sink." In 1930, South Carolina had the highest illiteracy rate in the nation, malaria was still a raging problem and the state was unable to pay its bills, instead using "state scrip" to pay state employees.

At the 1932 Democratic Party Convention, Franklin D. Roosevelt, a candidate for the nomination of president, was speaking of the advantages of federal programs for public works. Convention delegates South Carolina Governor Ibra Blackwood and Charleston Mayor Burnet Maybank attended these meetings and proposed that the federal government take over the Santee Cooper Project.

In 1933, State Senator Richard Jefferies sponsored a bill, with twenty-five of the forty-six senators cosponsoring, to create a public corporation. The bill passed the Senate but was

defeated in the House. The bill opposition was generated by three groups of detractors. Some felt that power production was not the purview of the state and should be left to private enterprise. Others felt strongly that South Carolina could not afford to fund such an ambitious project. Finally, influential St. John's Parish residents and wealthy Northern industrialists, wanting to protect their hunting preserves, lobbied against the bill.

Harry Ashmore, a Greenville journalist, wrote, "South Carolina is seeking to rehabilitate that region [St. John's] to bring wealth not to a few as in other days, but prosperity to many. A vision of an industrial empire in a virgin land has taken hold of this state…There is a dream of repopulating a vast area."

A new committee was formed, including a young legislator from Edgefield, J. Strom Thurmond. New legislation was proposed citing four goals for the project: "1) To provide affordable electric power for South Carolina; 2) To develop the Santee, Cooper and Congaree rivers for navigation; 3) To reclaim and drain swamp lands; and 4) To reforest the watersheds of the state's rivers." In February a committee of sixty-four South Carolina officials and citizens traveled to Washington to meet with the Public Works Administration and the Works Progress Administration.

On April 7, 1934, Governor Blackwood signed the bill to create the South Carolina Public Service Authority, popularly known as Santee Cooper. Blackwood appointed Burnet Maybank as the first chairman. President Roosevelt wrote in July 1935, "From my study of the Santee Cooper project, I am convinced that its construction, which can be speedily put underway, will not only serve to overcome the distress caused by unemployment in that section, but will also permanently contribute to the economic development of the southeast."

Not to be deterred, opponents filed a lawsuit to block the act. On September 10, 1935, the South Carolina Supreme Court ruled that the Santee Cooper act was constitutional. Still determined to forestall the project, Carolina Power & Light Company, South Carolina Power Company and Broad River Power Company filed a federal lawsuit. They argued that the project cost would far exceed the estimates, that the lakes were geologically unsuitable and that the project would "do an irreparable injury to the majority of the people of SC."

In 1937, Federal Judge J. Lyles Glenn ruled in favor of the Santee Cooper Project. The decision was appealed to the U.S. Supreme Court, which upheld the decision on May 3, 1938. Initially a $14 million federal grant was awarded and additional loan guarantees totaled $17 million, a total figure that was two and a half times the size of the entire 1939 South Carolina state budget.

The United States Department of the Interior sent a consultant, Thomas T. Waterman, to assess the value of the historic homes that were threatened by the project. Considering all the plantation homes, he recommended that only Hanover and the Rocks were worthy of preservation, a view that would be disputed today, given the large number of historic homes lost to the project.

The project took two years, six months and twenty-six days from the first clearing to the flooding of the lakes. The navigation lock at the Pinopolis Dam was the highest single-lift lock in the world, lifting boats seventy-five feet from the Tailrace Canal to Lake Moultrie.

The project created two lakes: Lake Moultrie, near Pinopolis, and Lake Marion, within the bluffs of the Santee River marshes, north of Eutaw Springs. Lake Marion is the larger of the two, but it is not completely cleared of thousands of stumps, dead tree trunks and live cypress

trees. Lake Moultrie is smaller but more open, measuring fourteen miles at the widest point. The project did open 86,000 acres to duck and goose hunting and 160,000 acres to fishing.

Today, Santee Cooper provides power to 1.7 million South Carolinians and to thirty-two large industries, municipal utilities in Bamberg and Georgetown and to the Charleston Air Base.

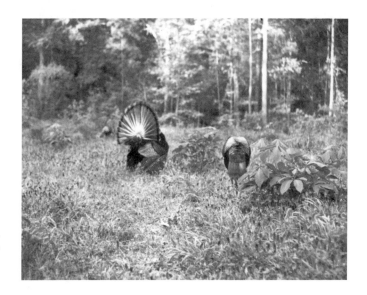

Game hunting was always both a sport and a necessity for food gathering in St. John's Parish. The plantation properties were teeming with wild turkeys, quail and deer.

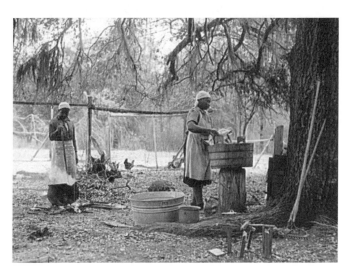

There were thousands of African Americans, mostly descendants of plantation slaves, living in the Santee Cooper basin. Poverty was rampant through the region. *Courtesy of the Library of Congress.*

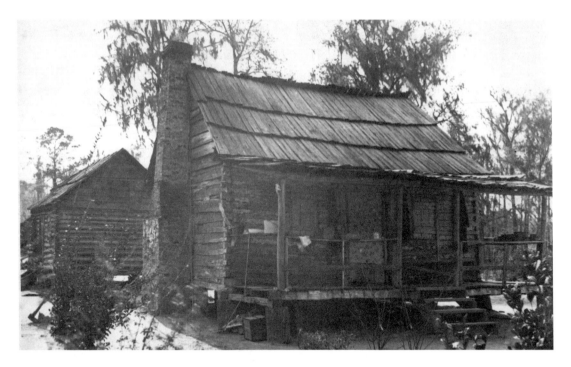

Many African American families were still living in old plantation slave cabins, structures that were well over one hundred years old. *Courtesy of Mrs. Roulain Deveaux.*

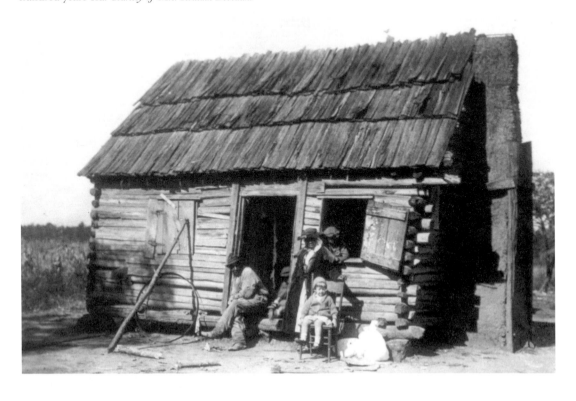

When asked about the Santee Cooper Project's offer to buy her property and move the family, one elderly black woman indicated her excitement saying, "Great Gawd, den I'd hab coffee an' macaroni pie t'ree time a day." *Courtesy of Mrs. Helen Schiller.*

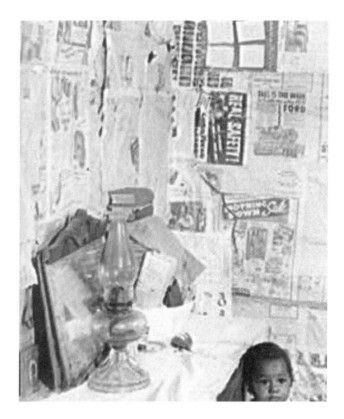

Right: These poor families held tightly to their few treasures, like a piece of furniture or a lace cloth. In this photograph, the family has insulated their cabin with newspaper in an attempt to trap any heat possible. By spring, this would strip away to escape the coming heat of Lowcountry summers. *Courtesy of the Library of Congress.*

Below: In the project, the Santee Cooper Resettlement Division relocated 901 families, most all black. Like the large plantation homes, most of these old cabins were destroyed. *Courtesy of the Library of Congress.*

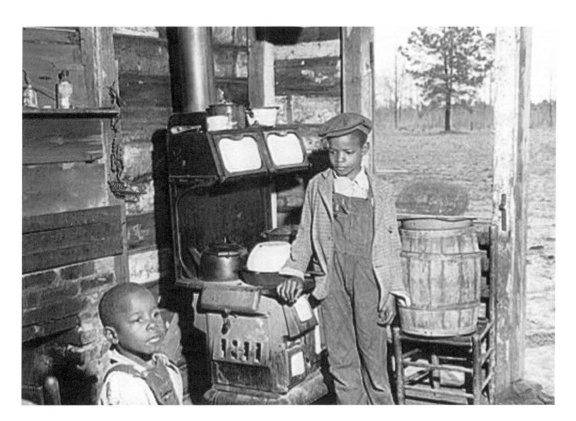

Left: There were few jobs available to the black families in St. John's by the early twentieth century. Most workers either farmed or timbered trees for turpentine. *Courtesy of the Library of Congress.*

Below: On the small African American farms in St. John's, everyone pitched in and worked. Charleston photographer George W. Johnson captured this photograph of children milling rice on the Cooper River. *Courtesy of Mrs. Roulain Deveaux.*

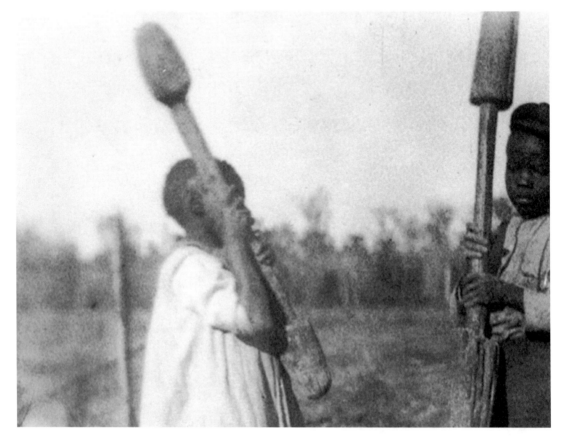

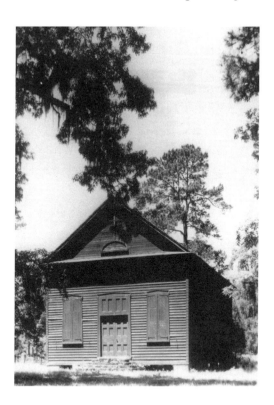

Numerous churches, black and white, were destroyed by the Cooper Santee Project. Black Oak Church, pictured here, was first established in 1808. The church was dismantled in 1941 and its graves were moved to St. Stephen's Episcopal Church and Pooshee Plantation.

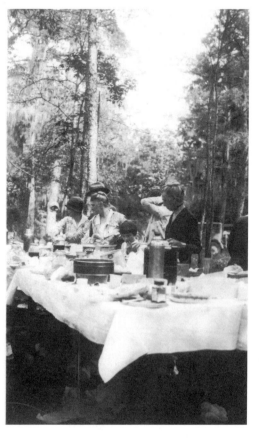

Black Oak Church was home to the Cain, DuBose, Jervey, Lucas, Porcher and Ravenel families, among others. Here the families gather for a covered dish lunch at the Black Oak grounds. *Courtesy of Mrs. Sarah Spruill.*

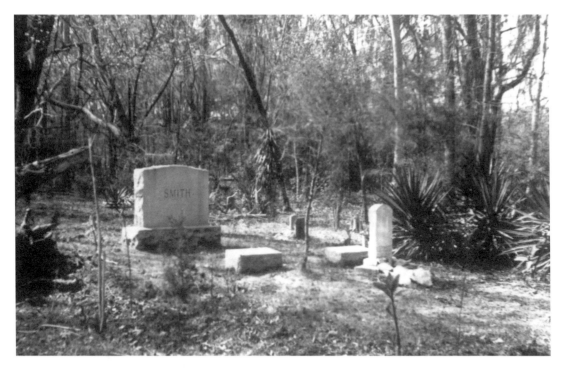

The Santee Cooper Project relocated ninety-three cemeteries throughout St. John's Parish, a massive project in itself. One resident offered that the upcoming flooding for the lakes "menaced the homes of the living and the graves of the dead."

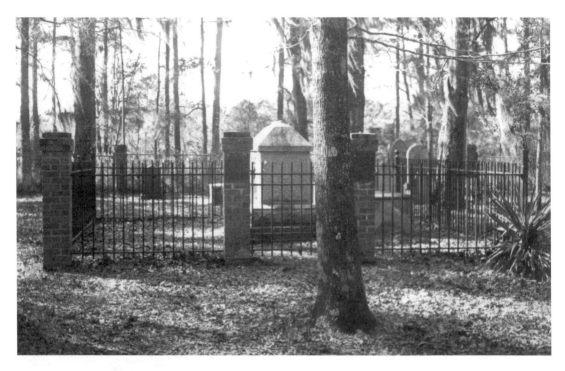

The graves of General Francis Marion and his family at Belle Isle Plantation, home of his brother Gabriel, survived the flood. Several Porcher grave markers were moved from Black Oak to join them.

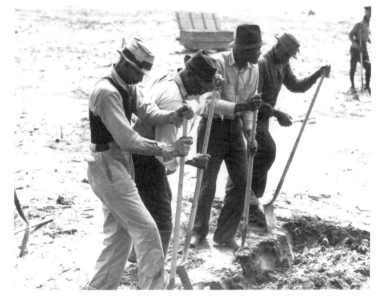

More than six thousand graves were relocated in the resettlement effort. Without ground-penetrating radar, which was not yet available, the relocation crews had to rely solely on markers of any type to locate the graves. Many colonial-era graves, whose cypress tomb boards had long since disappeared, would never be discovered.

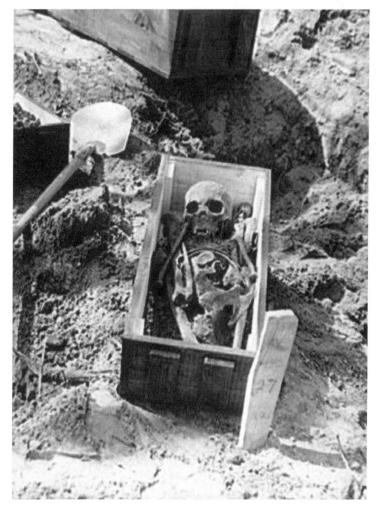

The skeletal remains were removed and placed in new caskets for re-interment. In many cases where tangible remains were no longer available, the grave markers were moved and concrete slabs were poured over the original gravesite. *Courtesy of the Library of Congress.*

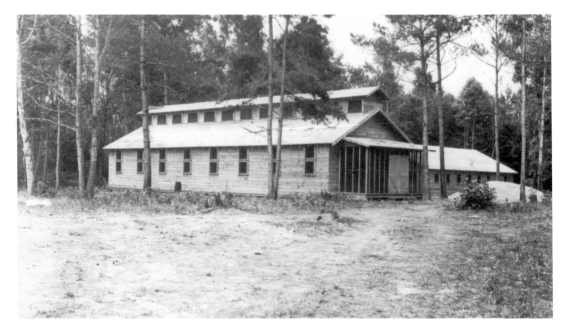

At the height of construction, more than 12,500 people were employed by the Santee Cooper project. Twenty-two work camps were constructed. Eleven of these were permanent and eleven camps moved as the work progressed. The men were housed in barracks and fed in large mess halls.

Separate barracks and mess halls were established for white and black workers. Some barracks were built for fewer men and more comfort. The quarters pictured here was for engineers and was much smaller and more comfortable than the large barracks built for laborers.

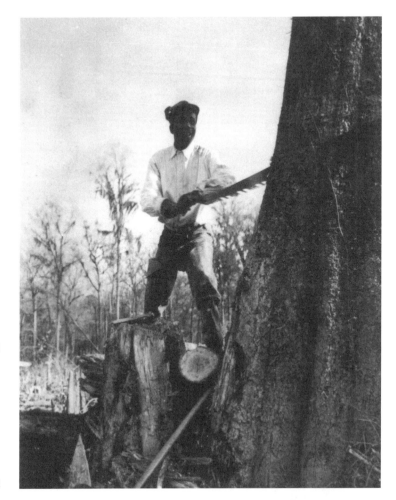

Right: The land was first cleared of trees using axes and crosscut saws, no small task for the thick virgin woodlands present in much of St. John's Parish.

Below: A total of 104 million feet of virgin hardwood were harvested in the Santee River basin. A total of 200 million feet of timber were cut and sold during the project.

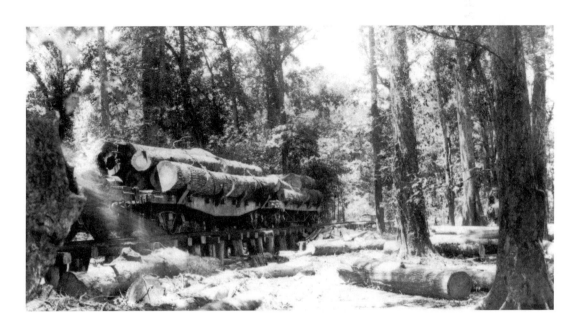

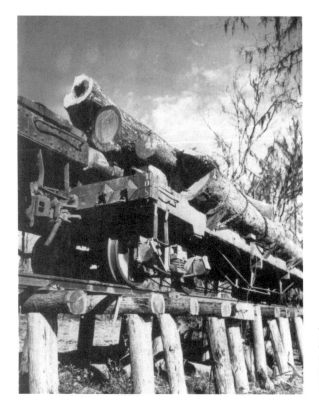

Temporary elevated rail lines had to be constructed to move the harvested timber out of the swamps and river basin. As with the barracks for the laborers, these tracks were moved and reassembled to the locations needed.

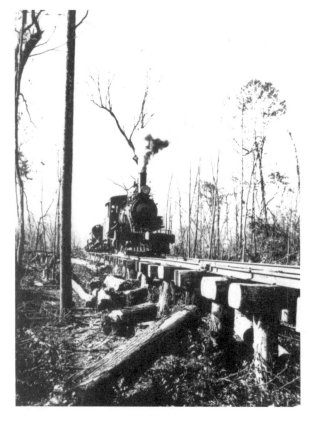

Nine thousand of the men in the workforce were assigned to logging, milling and clearing. Particularly given the era in which this was done, the Santee Cooper Project was a model of ingenuity and efficiency.

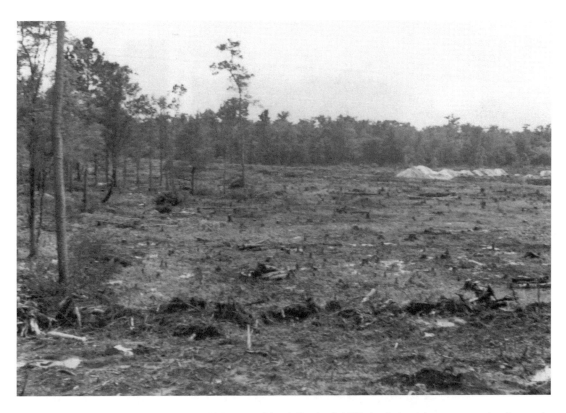

The project required obtaining title to 1,326 tracts of land. By April 1939, land clearing crews were hard at work. By June of that year, Santee Cooper had acquired 1,100 of the needed properties totaling more than 177,000 acres. An average of $12.19 per acre was paid for farmland.

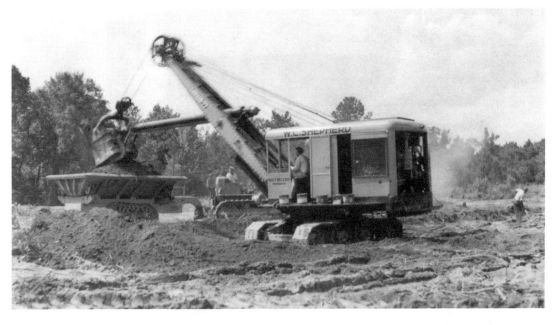

Once the trees were removed and shipped out for sale, many areas still had to be excavated. Though steam shovels were used, the progress was slow.

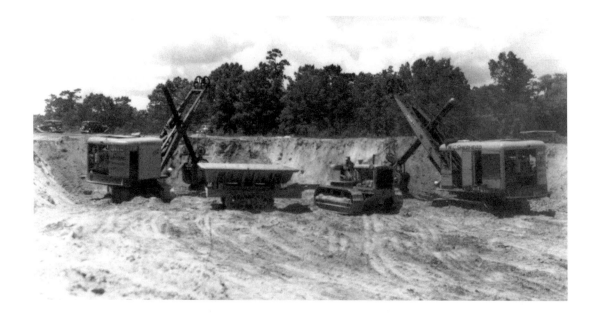

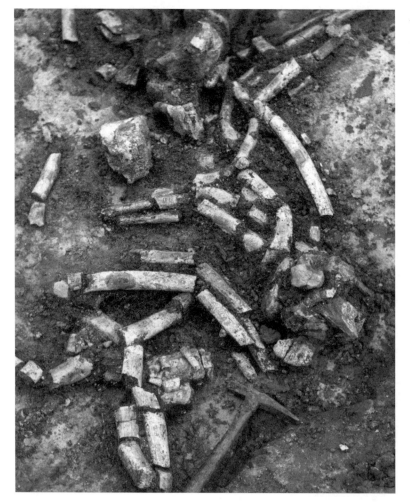

Above: Once completed, the Santee Cooper Project was one of the largest land-clearing projects in the history of the United States.

Left: During excavation, many archaeological sites were uncovered, including unknown burial sites and many Native American sites. This photograph was taken at one site where a set of whalebones was uncovered.

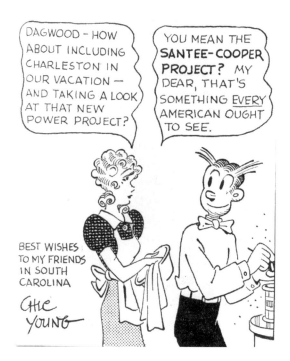

In December 1941, the Charleston *News and Courier* published a special "Power and Defense" issue featuring best wishes to Santee Cooper from some of the popular comic strip characters.

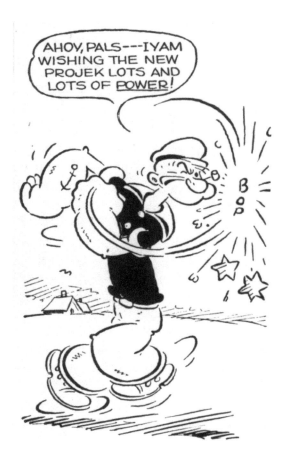

The Santee Cooper Project was not without its detractors. While the land purchase and clearing project were fully supported by the state and, if needed, the courts through eminent domain, the Board of Directors was committed to winning in the court of public opinion as well.

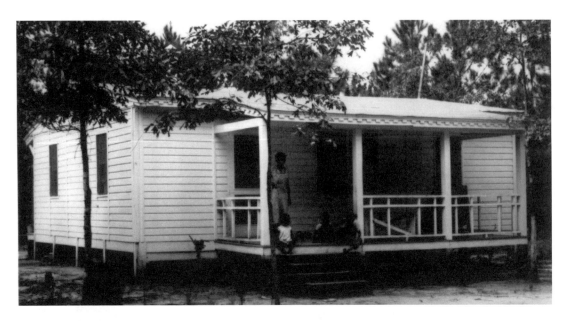

When families had to be relocated, their houses were moved if possible. Many of the African American cabins and shacks were not worth saving. In that case, a new home was built for the family.

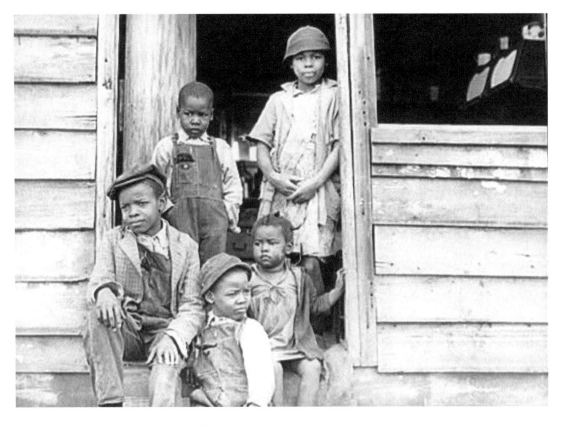

Santee Cooper moved families and neighbors to new sites together to maintain these important rural relationships. One hundred chickens also provided for every family that had to be relocated. *Courtesy of the Library of Congress.*

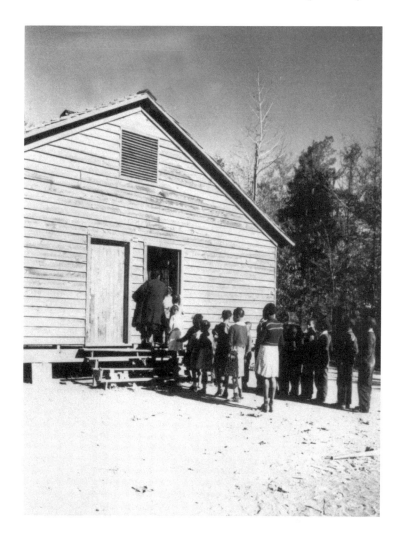

When new communities were created, schoolhouses were also constructed to provide for the families. Most of the African American families that were relocated viewed the benefits provided as a windfall.

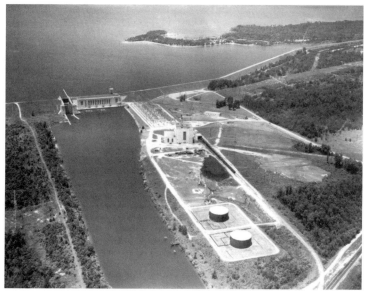

On November 12, 1941, the reservoir began to fill. By February 17, 1942, the Pinopolis Hydroelectric Plant produced its first electricity.

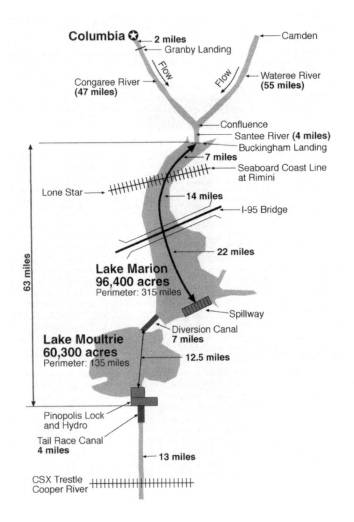

Columbia ⊙ — 2 miles
— Granby Landing
← Camden

Flow Flow

Congaree River → (47 miles)
Wateree River → (55 miles)

— Confluence
— Santee River (4 miles)
— Buckingham Landing
— 7 miles
— Seaboard Coast Line at Rimini

Lone Star →
— 14 miles
— I-95 Bridge

— 22 miles

63 miles

Lake Marion 96,400 acres
Perimeter: 315 miles

— Spillway
Diversion Canal 7 miles

Lake Moultrie 60,300 acres
Perimeter: 135 miles
— 12.5 miles

Pinopolis Lock and Hydro
Tail Race Canal 4 miles
— 13 miles

CSX Trestle Cooper River

Left: The Santee Cooper Project created Lake Marion (110,600 acres) and Lake Moultrie (60,400 acres), joined by a 7-mile diversion canal. The lakes vary in depth from shallow swamps to 30 feet.

Below: The two lakes offer world-class freshwater fishing. They hold the world record for channel catfish, fifty-eight pounds. They did hold the world record for striped bass, fifty-five pounds, through 1977. The lakes also hold state records for largemouth bass, black crappie, chain (Jack) and Arkansas blue catfish.

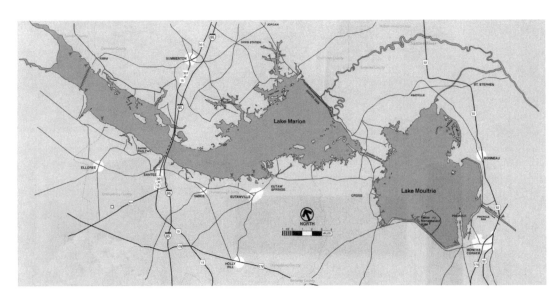

PART II
The Plantations

The region of the Lowcountry that became St. John's Parish was located approximately fifty miles from Charleston, from the Cooper River northwesterly to the Santee River. The families settling these lowlands included some of English descent; some, like the Sinklers, of Scottish descent; but most of the settlers were French Huguenots.

In 1598, Henry IV of France, trying to end the French Wars of Religion, issued the Edict of Nantes granting equal rights to the Protestants living in a Catholic nation. In 1685, Louis XIV, the grandson of Henry IV, revoked the edict and declared Protestantism to be illegal. Many of these Protestants, known as French Huguenots, fled to Great Britain, Prussia or Switzerland to avoid persecution. Others made the arduous journey to the colonies in America.

Many of these Huguenots, like the Porcher, Gaillard, Mazyck, Palmer, Ravenel, Marion and Gourdin families, settled in St. John's Parish. The country was relatively isolated by its distance from Charleston. Reaching Charleston required a ride on the river barge or, by 1833, taking your carriage twenty miles away to Branchville to catch the train.

A map of St. John's Parish in 1865 was inscribed, "Here dwelt a people in peace and contentment, whose ancestors fled from tyranny in other lands. They tilled the ground and roamed the forests and, at last, all was well with their world."

Indigo and rice brought prosperity to St. John's, but in most cases their fortunes were made growing Santee long-staple cotton. This hybrid between upland cotton and the famous sea-island cotton created wealth for St. John's planters never realized before. The Santee long cotton would never quite match the quality of sea-island cotton, but it was highly sought at the markets and abroad.

As the Santee Cooper Project was debated in the South Carolina Legislature, Greenville journalist Harry Ashmore wrote:

> *Today thousands of acres of the South Carolina Lowcountry, once fertile fields and the foundations of fortunes and culture, lie idle and forgotten save perhaps by a few sportsmen, by waterfowl and swamp game…The march of progress and civilization has left in its wake*

decaying mansions, specters now of a more glorious day, silent and vacant in their watch over the lands where once their masters reaped crops of large return, of indigo and rice.

Ashmore's point was well taken, but, in fact, many of the plantations in St. John's, by the turn of the twentieth century, were still cultivated and inhabited by the descendants of the colonial and antebellum owners. Neither rice nor cotton was cultivated in large numbers. Henry Edmund Ravenel recorded, in 1898, "To this day the labor of the section of country which we have in view remains completely demoralized. Nor has any substitute for cotton yet appeared, not indeed any crop which may be expected to enrich the country."

Many planters were trying their luck at truck farming or dairy operations. Northern industrialists, with ready cash, were buying up lands to create hunting preserves and chasing the myth of becoming the "Southern planters."

BELVIDERE PLANTATION

Belvidere Plantation, built in 1786, was one of the earliest cotton plantations built in the region. Captain James Sinkler, a resident of St. Stephen's Parish, obtained a grant to this property in 1770. The critical Revolutionary Battle of Eutaw Springs was fought on part of the Sinkler property in 1782. The beautiful property was bordered on the north and south by two streams.

After the Revolution, Captain Sinkler was one of the first in St. John's Parish to plant cotton. His cultivation and fertilization techniques resulted in harvest yields of more than two hundred pounds per acre, making his enterprise most profitable. Sinkler's overseer developed an efficient method of compressing cotton into bales, allowing the raw product to reach market promptly. The overseer lived on the Belvidere property while Sinkler maintained his residence at "Old Santee."

Sinkler died in 1800 and his widow, Margaret Cantey Sinkler, built the plantation house and moved the family to Belvidere. Their grandson, Charles Sinkler, and his wife, Emily Wharton Sinkler, moved to Belvidere in 1848. Using Emily's correspondence to her family in Philadelphia and her plantation receipt book, antebellum life at Belvidere Plantation is detailed in a marvelous book, *An Antebellum Plantation Household*, by Anne Sinkler Whaley LeClercq. Charles cultivated the property to good effect and, prior to the war, he had 195 slaves working the property.

In addition to their prowess in cotton cultivation, the Sinklers were avid hunters and horsemen. Their blooded stock of thoroughbreds held a well-deserved national reputation as excellent racers. The popularity of horse racing in St. John's Parish led to the founding of the Santee Jockey Club in 1791. This enthusiastic club of sportsmen, later renamed the St. John's Jockey Club, held its races at the Belvidere track.

A fascinating ritual is detailed in LeClerq's book, as written by Emily Sinkler. Each horse owned or trained at Belvidere Plantation was assigned a slave groom. Every morning the grooms were assembled with their horses for inspection. The head groom distributed white gloves to his charges and instructed them to run their gloved hands over their horses. The grooms then assembled in line with gloved hands palms up for inspection. If any dirt or grime was visible, the groom was disciplined and the horse was bathed again.

Mrs. Elizabeth Allen Coxe, daughter of Charles Sinkler, recorded life at Belvidere in *Memories of a South Carolina Plantation During the War.* She noted when the guns of Charleston unleashed their barrage on Fort Sumter, signaling the start of the War Between the States, the enormous sound of the bombardment could be heard at Belvidere, sixty miles away. Sadly, at the war's end, the Sinkler family could also see the glow in the sky from Sherman's burning of Columbia in 1865.

In 1883, Charles St. George Sinkler, the son of Charles and Emily, took over management of the plantation. He continued to plant Santee long-staple cotton until his death in 1934. The plantation passed to the heirs of Charles Sinkler, Mrs. W. Kershaw Fishburne, of Philadelphia and Gippy Plantation (Berkeley County, South Carolina), and Mrs. Dunbar Lockwood of Boston. The plantation property continued to be extensively planted until taken by the Santee Cooper Project.

The Sinkler descendants emptied and dismantled the plantation house in 1941, distributing the Belvidere treasures among the family. The grand plantation, owned by the Sinkler family for 171 years, was claimed by the muddy waters of the Santee.

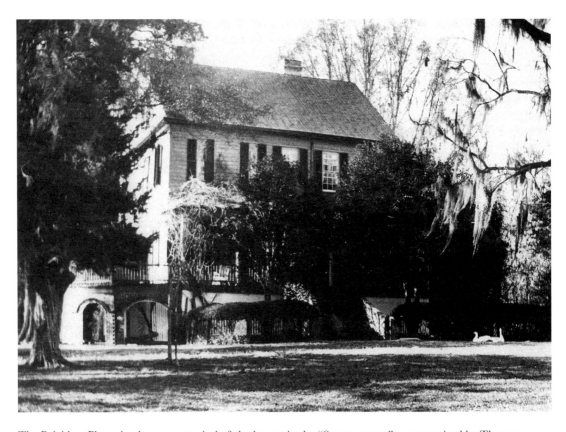

The Belvidere Plantation home was typical of the houses in the "Santee group," as categorized by Thomas Waterman in 1941. The house was a frame house on an open brick foundation, two stories tall, facing east and overlooking an expansive lawn. *Courtesy of Anne Sinkler Whaley LeClercq.*

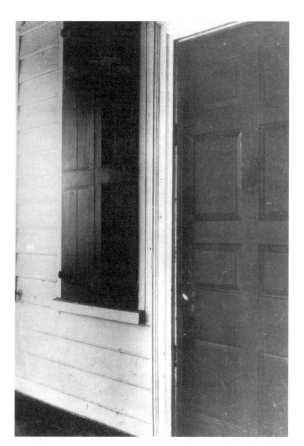

The house featured two unequal rooms on the front and a central hall flanked by two rooms in the back. Given no central hall extending to the front, each front room had its own front door.

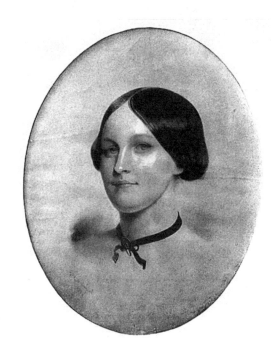

This portrait is of Emily Wharton Sinkler, the wife of Charles Sinkler. Her letters and receipt book were published in *An Antebellum Plantation Household* by Anne Sinkler Whaley LeClercq. *Courtesy of Anne Sinkler Whaley LeClercq.*

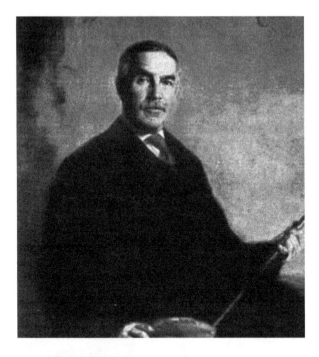

This portrait of Charles St. George Sinkler hung in the Belvidere house. Sinkler, the second son of Charles and Emily Sinkler, farmed at Belvidere from 1883 to 1934. *Courtesy of Anne Sinkler Whaley LeClercq.*

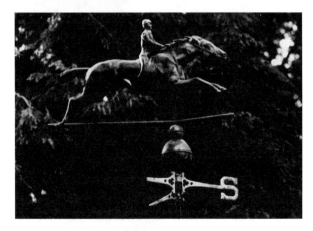

When Belvidere was dismantled, Anne Sinkler Fishburne removed the family wind dial, placing it on her porch. The ornament was reminiscent of the great racing heritage at Belvidere. The Sinkler wind dial always points south. *Courtesy of Anne Sinkler Whaley LeClercq.*

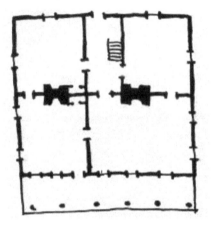

This interesting house design provided for privacy for the family in the front rooms, as servants could go about their chores using the back stairwell. The expansive front porch was an important feature in beating the summer heat.

BUNKER HILL PLANTATION

Bunker Hill was originally part of Hogswamp Plantation in upper St. John's Parish. Dr. Edmund Ravenel inherited a portion of the property from the estate of his father, Daniel Ravenel of Wantoot Plantation. Dr. Ravenel practiced medicine in Charleston and never lived at Bunker Hill.

In 1836, Ravenel sold his plantation to William Dennis, his overseer. He lived there for eighteen years before selling the property. In 1855, Harlock Huxford Harvey acquired the plantation. The plantation stayed in the Harvey family until Santee Cooper acquired it in 1939.

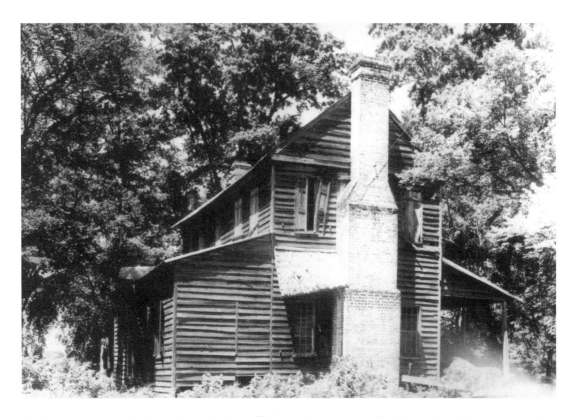

By 1939, the house was being used as a hay barn. The grounds were covered with weeds and thick undergrowth.

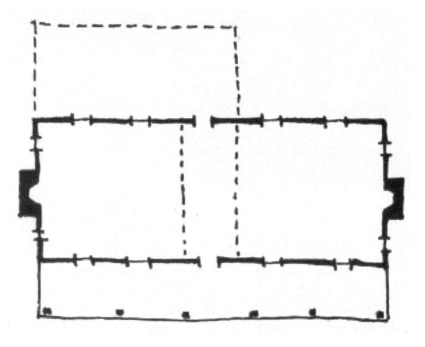

The house, built after 1800, was typical of what Waterman called the "Pinopolis group," featuring a central hall design.

CEDAR SPRINGS PLANTATION

Cedar Springs was located just north of Ferguson Swamp and eight miles from Pinopolis in upper St. John's Parish. Formerly known as "Buffalo Hole," the plantation derived its name from the large and curious sinks on the property.

Professor Frederick A. Porcher, grandson of the first owner, writes in 1868: "Hereabouts are several remarkable sinks in the earth, which were formerly supposed to be Buffalo Licks; afterwards extinct fountains…These bottoms are firm enough to support a man's weight, but although very deep, they never hold water."

Philip Porcher, of Oldfield Plantation in St. Stephen's Parish, acquired this property prior to the Revolutionary War. As he prepared his will late in life, he was upset that he didn't have enough properties in St. Stephen's to leave one to each of his sons. Though he owned Cedar Springs, he did not believe his St. John's plantation could be cultivated to be as prosperous as his other holdings. Nonetheless, he left Cedar Springs to his son George.

George Porcher moved to Pineville and built his home at Cedar Springs in 1804. Ironically, the wealth derived from George's property far exceeded that of his brothers. In 1813, George was visiting the plantation and was killed by his horse in a freak accident. His widow, Marianne, enlarged the house in 1825. After her death in 1835, her son, Dr. John Palmer Porcher, acquired the plantation.

In March 1865, a company of black Union soldiers raided the plantation. The soldiers found the plantation occupied by Mrs. Porcher and her young son, George. Her husband, John Palmer Porcher Jr., had died several months before. The soldiers seized the food and provisions at Cedar Springs for their use. That evening their captain and several others dined in the Porcher home. At the end of the meal, the black captain left with a souvenir, the silver butter knife and spoon he had used. Even though the widow and her son lost their food and provisions, the soldiers left the next day without burning the home, as they had with many other St. John's properties.

The property eventually passed to Isaac de C. Porcher, reputed to be "the last surviving pure-blooded Huguenot in America." At the time Santee Cooper acquired the Cedar Springs property, the plantation was owned by Percival Porcher III and Richard Dwight Porcher,

nephews of Isaac Porcher. In front of the house was evidence of an old airplane landing strip, the windsock still blowing in the breeze.

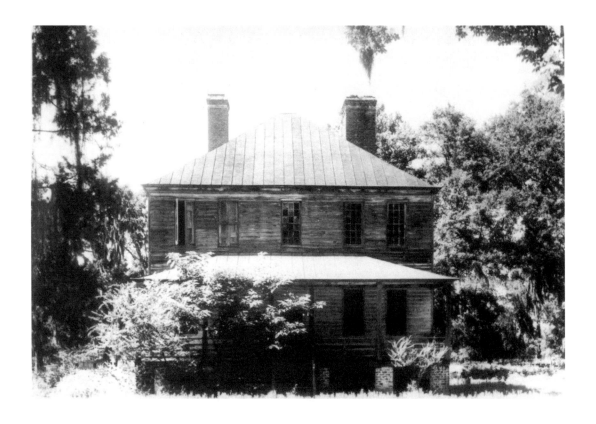

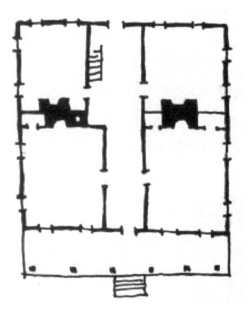

Above: The house was similar in design to White Hall Plantation, though smaller in size. Owned by the Porcher family for five generations, the condition of the home in 1939 betrayed that the house was no longer inhabited.

Left: The house, typical of the Pinopolis group, featured a central hall flanked by rooms in front and back. Santee Cooper destroyed the house after acquisition.

EUTAW PLANTATION

James Sinkler, of Old Santee in St. James Parish, acquired a grant prior to the Revolutionary War that included tracts of land that would later divide into Belvidere and Eutaw Plantations. The name "Eutaw" is derived from nearby Eutaw Creek, which flows from the Eutaw Springs.

As whites settled the area in the late seventeenth century, they encountered a Native American tribe named Eutaw that hunted along the creek. The Eutaws, also known as Etiwans, were part of the Cusabo linguistic group.

In 1808, a fine house was built on the Eutaw property for James's son William on the occasion of his marriage. The tract of land divided for William was on a bluff of the Eutaw Creek approximately one mile west of the Eutaw Springs battlefield.

William Sinkler, like others in his family, was an avid horseman and breeder. When he moved to Eutaw he built a one-mile track to the east of the oak allée leading to his house. Hercules, a slave owned by Sinkler, was an expert trainer, preparing horses owned by Sinkler and others for racing. Hercules, or "Old Hark" as he was known, had earned a national reputation for the great race horses he trained.

Albine was foaled in 1856, owned by Peter G. Stoney. Stoney sent the filly to Bullfield Plantation in Virginia to be trained by the stables of Major Thomas Doswell. Doswell, responsible for training many national champions, returned the young filly to Stoney noting that the horse would never succeed as a competitive racer.

Stoney sold the horse to John Cantey in 1859. That same year Colonel James Ferguson and Cantey hired Hercules to train Albine. By December of that year, Albine won a one-mile race for three-year-olds in Camden. Hercules continued to train Albine, running her occasionally at the Pineville racetrack.

Hercules suggested Albine was ready for Charleston Race Week in February 1860. Albine shocked the Charleston race community by winning the two-mile "Jockey Club" race. Throughout 1860, Hercules continued training the filly, winning two races in Camden, each time defeating a horse owned by Major Doswell of Virginia.

Doswell, looking for revenge, entered his national champion, Planet, to race against Albine in the upcoming Charleston Jockey Club race in February 1861, a four-mile match race. Shocking all in attendance, Albine not only defeated Planet, but in doing so set a national record at seven minutes, thirty-six and a half seconds. This record still stands in the annals of

thoroughbred racing. For the remainder of his life, Hercules could never buy his own food and drink whenever he came to Charleston.

In February 1865, Union General Hartwell conducted raids throughout St. John's Parish and established Eutaw Plantation as his headquarters. The women of the Sinkler family were relegated to the second-floor living quarters, while Hartwell and his staff made use of the main floor. The Sinklers had buried thirty-four chests of clothes, china and silver on the grounds. The Union soldiers located the valuables buried near the blacksmith shop and stole the family possessions.

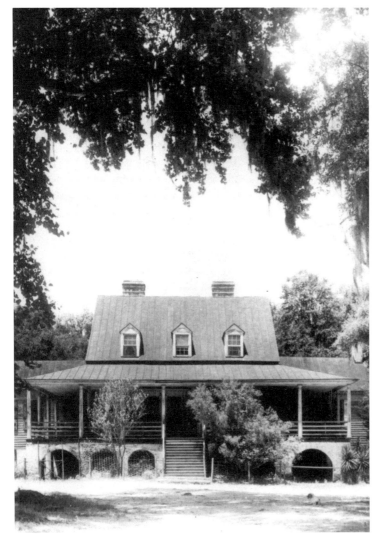

Eutaw Plantation never passed out of the Sinkler family until Santee Cooper acquired it. The house, built in 1808, was a large, roomy house built high off the ground.

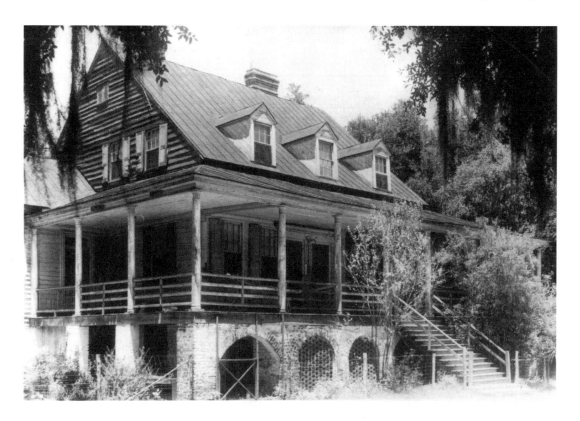

Above: The house featured a wide piazza that wrapped around three sides. The piazza columns were made of solid cypress. Cypress weatherboards covered the house.

Right: When entering the plantation, visitors traveled a long, impressive oak allée to reach the house. The gardens at Eutaw were famous throughout the state. One of the Sinklers' gardeners was reputed to be the grandson of an African king. *Courtesy of Mrs. Sarah Spruill.*

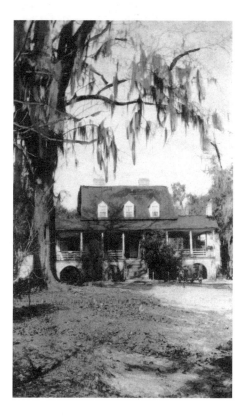

Left: The interior woodwork was simple compared to other St. John's homes, but dignified in appearance. The hand-carved mantel was thought to have been purchased and brought in from out of state.

Below: The low spreading roof and huge piazza were reminiscent of the Carolina-Caribbean home style, popular in lower St. John's Parish. The large home was destroyed after Santee Cooper acquired the property.

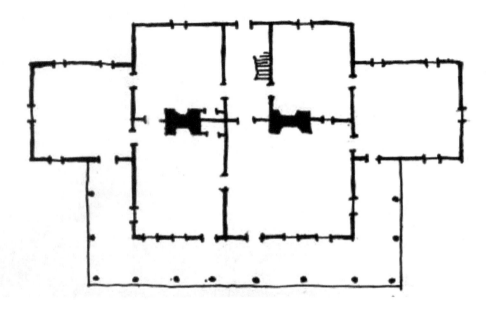

HANOVER PLANTATION

In 1688, the Lords Proprietors granted a French Huguenot immigrant named St. Julien three tracts of land in Carolina. In 1716, a grandson, Paul St. Julien, built a home and named the plantation Hanover in honor and thanks to the House of Hanover, which had come to the British throne. The St. Julien family and other French Huguenots were eternally grateful to the British throne, which had befriended the French refugees after the revocation of the Edict of Nantes.

Hanover Plantation house, with the house at North Hampton, was the oldest remaining house in St. John's Parish by seven decades. The blend of French and English construction techniques is unique in the historic homes extant in the United States. The house has many interesting and unique features. The north foundation was constructed with gun-slots for defense.

In 1750, Henry Ravenel married Mary de St. Julien and moved to Hanover Plantation the next year. The plantation remained in the Ravenel family for the next 188 years. Two members of the family, brothers Stephen and Daniel Ravenel, both served as secretary of state for South Carolina in the early nineteenth century.

In 1939, when Santee Cooper acquired the Hanover property, the plantation was owned by a syndicate led by J. Russell Williams of Moncks Corner, South Carolina.

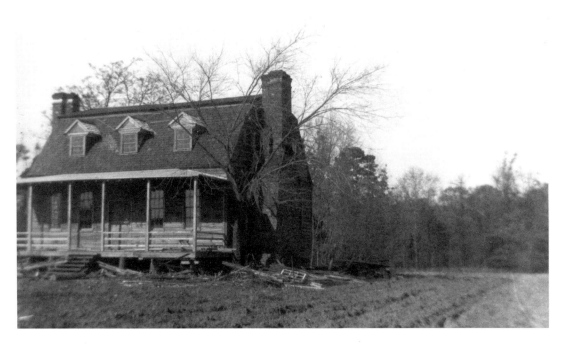

In 1939, when surveyed, the Hanover house was surrounded by unkempt fields and encroaching woodlands. The house was as neglected as the grounds. When the house was dismantled in 1939, it was discovered that everything from the frame to the flooring to the shingles was made of native cypress. *Courtesy of Mrs. Sarah Spruill.*

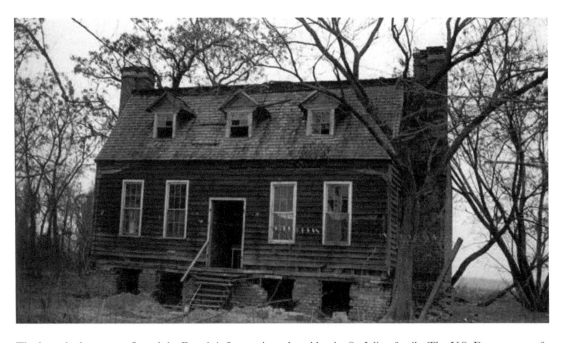

The home's character reflected the French influence introduced by the St. Julien family. The U.S. Department of Interior reported that "no other 18th-century examples of French provenance are known in this country, leaving the Hanover house of national historic importance."

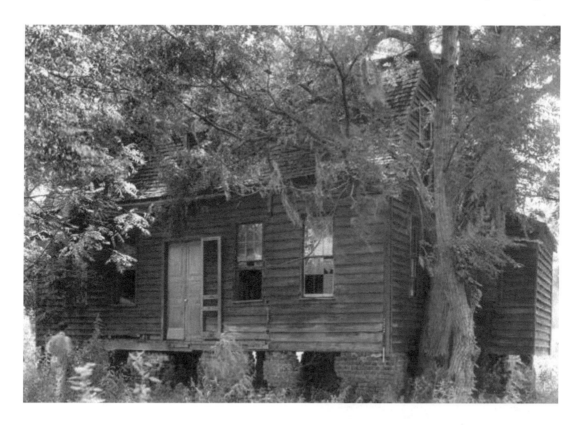

Above: The house was constructed of wood, entirely cypress. By 1939, the original trim woodwork inside had disappeared. Waterman felt that the one-and-a-half-story house with the full basement gave Hanover a "medieval character."

Right: The rear entrance was a double door featuring two vertical panels with a square panel in the center. This design was typical of the period of construction.

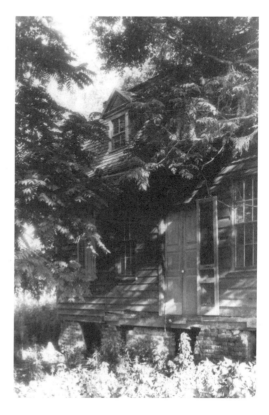

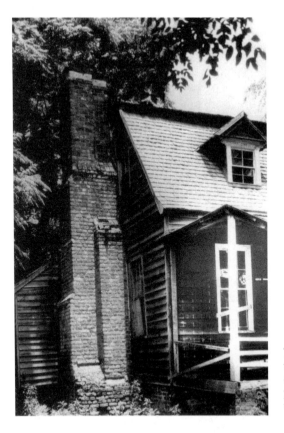

The two end chimneys attracted much attention when surveyed, each featuring three flues, one from each story. The chimneys were built of multicolored plantation brick and assembled with a mortar made with marl mixed with shell.

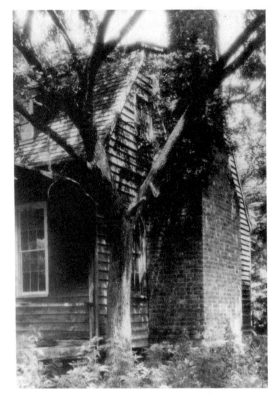

A band of stucco on the top of the chimney bore the inscription "Peu a Peu." This is taken from an old French proverb, "Peu a peu l'oiseau fait son nid," meaning, "Little by little the bird builds its nest."

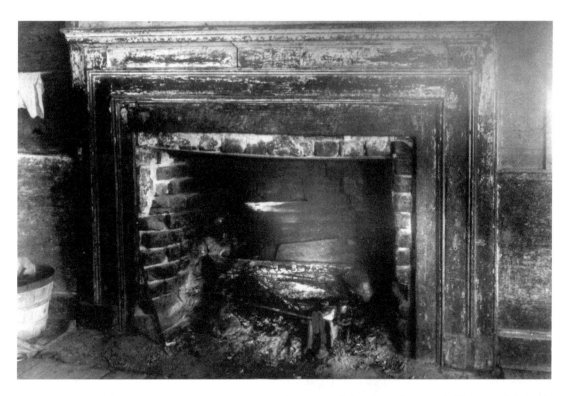

The mantels in the front rooms are later additions or replacements, dating from about 1800. The mantel design is certainly simple compared to the nineteenth-century houses in St. John's Parish.

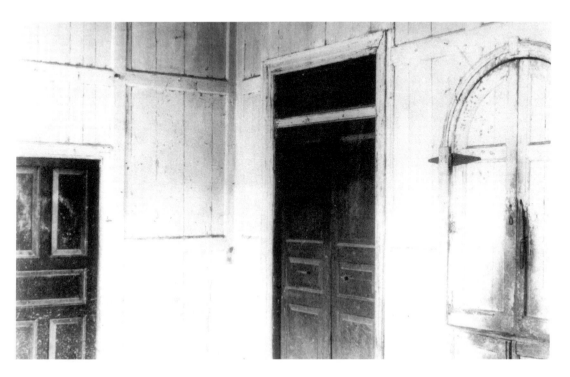

The interior walls are made of vertical boards affixed to the ceiling and floor. The horizontal boards were added to stabilize the vertical sheathing.

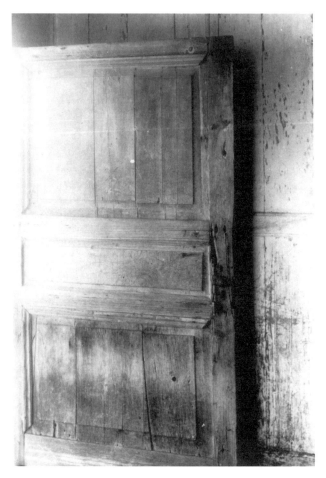

Left: The front door, four feet two inches wide, features a paneled French style. Waterman reported that this door was "unique in this country and so completely French in character as to be indistinguishable from a typical French door."

Below: The barn was the only remaining outbuilding left on the plantation by 1939. Being of no particular historic or architectural importance, it was destroyed once Santee Cooper acquired the plantation. *Courtesy of the Library of Congress.*

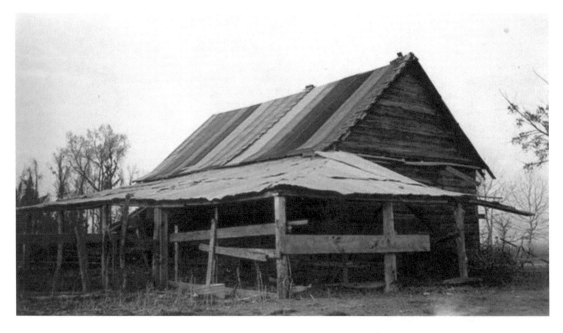

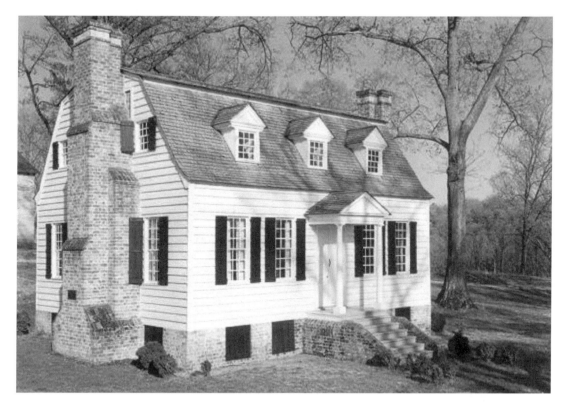

The Hanover house was saved and reconstructed at Clemson University in Upstate South Carolina. The house was completely restored and opened in 1962. In 1994, the eighteenth-century home was relocated to the campus's Botanical Garden.

INDIANFIELD PLANTATION

Thought to be part of an original St. Julien grant, this stunning property was listed on early plats as "South Hampton," found just south of General Moultrie's North Hampton Plantation. The plantation was known for its massive oaks and the crystal clear stream flowing through the grounds. Legend held that this property was a popular camping ground for Native Americans.

William Mazyck, a Charleston merchant, married his first cousin Elizabeth, the daughter of Philip Porcher of Oldfield Plantation in St. Stephen's Parish. This association with Porcher led to an interest in agriculture. William began by planting on his father-in-law's plantation. Using the profits from this venture, he purchased the property he named Indianfield.

In 1816, invitations were extended throughout St. John's and St. Stephen's Parishes for a grand house raising at Indianfield. Thus began a tradition of hosting social events at Indianfield that would continue for many years. The plantation was the site of many of the biannual dinners of the St. John's Hunting Club.

Dr. Henry Ravenel of Pooshee Plantation bought Indianfield in 1845 and later willed the property to his daughter Henrietta. When Woodboo was burned in 1865, Ravenel's son, Thomas Porcher Ravenel, moved to Indianfield, living there until his sister was ready to make it her home.

When the War Between the States began, Percival Porcher enlisted in the Charleston Light Dragoons, the only company in the Confederacy for which you had to be invited to enlist. The roster of this elite company reflected many men of privilege from the state's wealthiest families. This led many people to believe that this company would never see serious action.

Early in the war, the Charleston Light Dragoons were posted at Pocotaligo riding as pickets along the Charleston-Savannah railway. The dragoons later served at Morris Island during the Union siege on Battery Wagner. By 1864, the Charleston Light Dragoons were sent to Virginia and became involved in the great conflicts of the war.

Percival's wife received news at Indianfield that he was wounded in Richmond. She dispatched a trusted slave, Robert, to bring Mr. Porcher home to recover. Unfortunately, by the time Robert arrived, Percival Porcher had already died of his wounds. Determined to

take Porcher back home for burial, Robert tried in vain to find transportation. Undeterred, Robert began walking the streets of Richmond calling out, "My young master, Mr. Percival Porcher of South Carolina, lies dead in a hospital and I want help to carry him back to his young wife."

Finally an officer nearby who was a Porcher cousin heard the call and escorted Robert to Robert E. Lee's headquarters. On hearing the news, Lee authorized an artillery wagon and honor guard to escort the fallen soldier to South Carolina. Years later, when Robert died, the family honored his devotion by burying him in the Ravenel family plot at Black Oak Church.

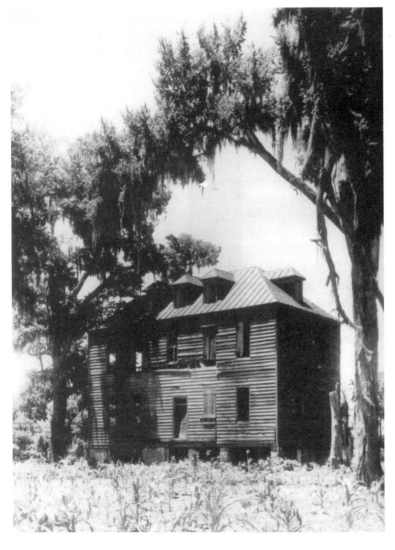

In 1939, Indianfield was owned by A.M. Barnes and Clarence Dillon of New York and was used as a hunting preserve. The house was long deserted and the interior finish had been stripped.

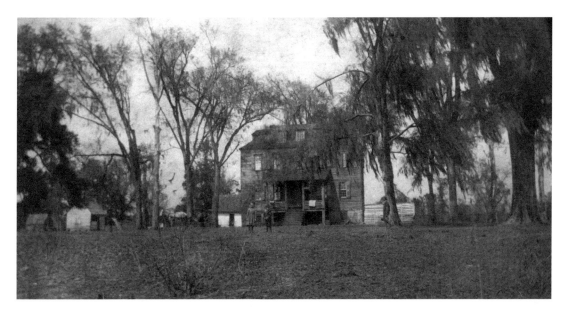

Located six miles west of Pinopolis, the plantation was in the area to be flooded by the lake. Once acquired by Santee Cooper, the Indianfield house was destroyed. *Courtesy of Mrs. Sarah Spruill.*

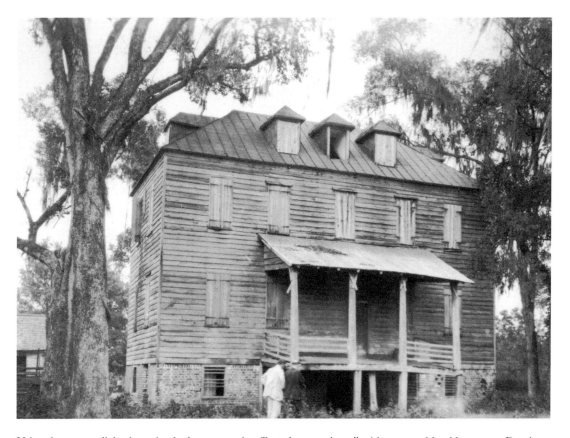

Using dormers to light the attic, the house was, in effect, three stories tall with a ground-level basement. Despite the poor condition of the house, it reflected a simple, though tasteful design. *Courtesy of Mrs. Sarah Spruill.*

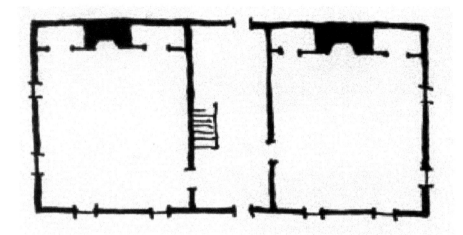

Most plantation homes in St. John's had four rooms on the first and second floors. Mazyck's design called for two large rooms on each level. With use of the attic, the house had six rooms and three central halls.

Mr & Mrs Thomas P. Ravenel

request the pleasure of your company at

the Marriage of their Daughter

Florence H.

Tuesday, December Thirteenth, 1881,

at 8 o'clock

Indianfield (St Johns) South Carolina.

Social occasions like weddings and society meetings were much anticipated in St. John's Parish. Being well removed from the social life in Charleston, St. John's residents relished a good reason to gather. *Courtesy of Mrs. Sarah Spruill.*

LAWSON'S POND PLANTATION

After the Revolutionary War, land in St. John's became highly desirable as planters sought fertile land conducive to growing cotton. Philip Porcher purchased Lawson's Pond in the early nineteenth century for just that purpose.

The plantation gets its name from a large pond found on the southwest side of the Congaree River Road (also known as the old Cherokee Path) near the point where the road intersects the Nelson's Ferry Road. The Lawson's Pond Plantation house was built just in front of the pond.

The date of the house is in dispute, but every account places the original construction between 1816 and 1823; it was thought to be built by Charles Cordes Porcher. Porcher built the house in anticipation of his pending marriage to Rebecca, the daughter of Francis (Dwight) Marion of Mount Pleasant Plantation. Unfortunately, Rebecca died in 1827, soon followed by the premature death of their infant child.

Charles Porcher died intestate in 1878 and his estate was indebted to a trustee for a marriage settlement between Peter J. Couturier and Elizabeth Sumter McKelvey. Dr. Joseph Palmer, administrator for the estate of Charles Porcher, sold the extensive furnishings and personal property to pay the trustee. Peter and Elizabeth Couturier took possession of the plantation in 1880. The plantation remained in the Couturier family through the twentieth century.

Santee Cooper only acquired a portion of the plantation property. The plantation house and some of the property was on high ground and would not be reached by the waters of the lake.

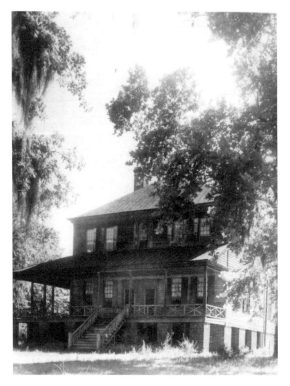

Left: The house is a large two-story structure sitting atop brick pillars. Underneath, massive hand-hewn logs held in place with pegs form the foundation.

Below: Waterman reported in 1939 that Lawson's Pond is perhaps the only house in the region that is as architecturally important as the stunning house at the Rocks.

Opposite above: The rear of the house has a single entrance opening to a small portico, though this portico is not original to the house.

Opposite below: The house features two front doors, each opening to one of the front parlors, a design typical of many St. John's homes.

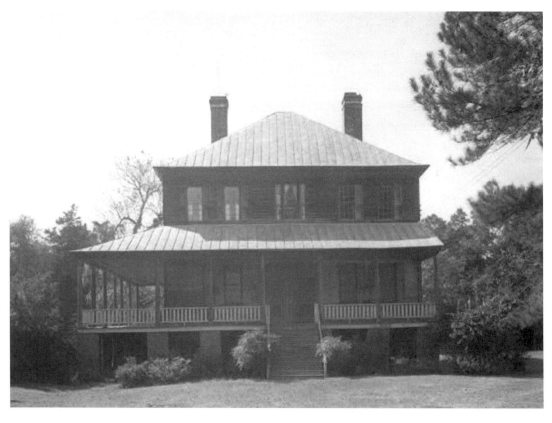

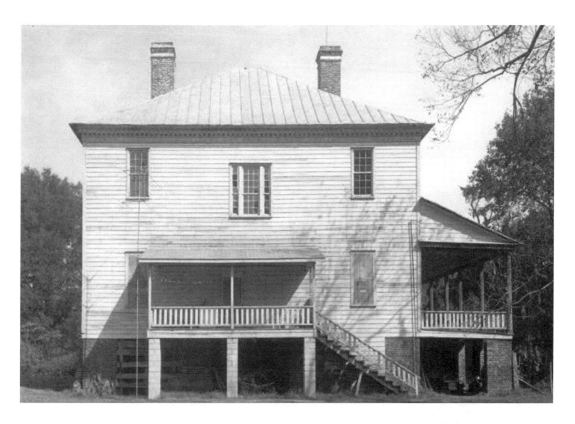

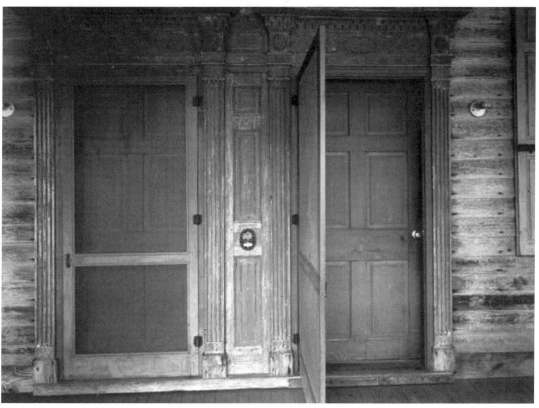

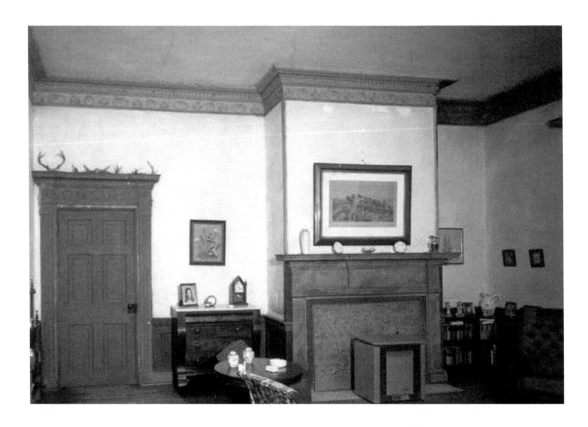

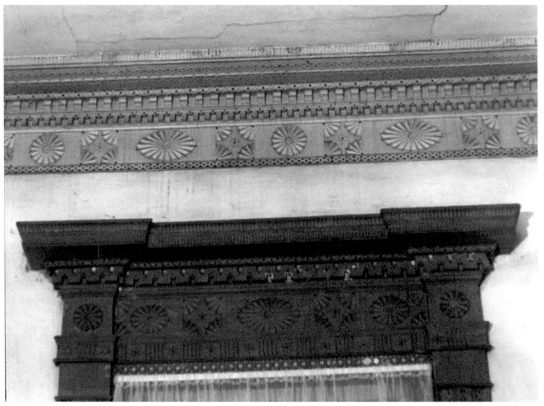

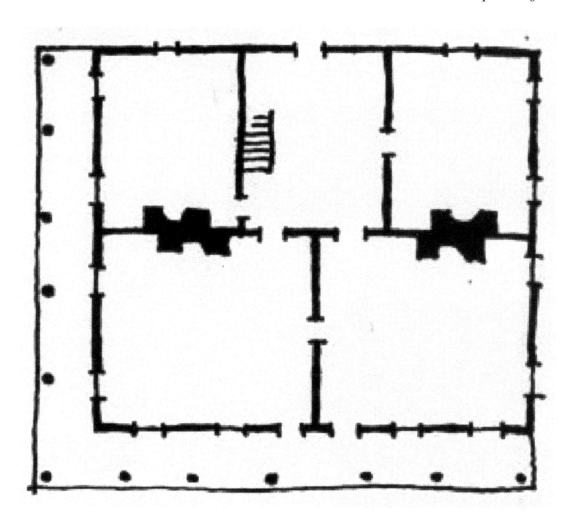

Sitting on high ground, the house was saved and has been restored. In 1977, the Lawson's Pond Plantation house was placed on the National Register of Historic Places.

Opposite above: The floor plan offers four rooms, each on two levels. This picture features the northwest front parlor on the main floor. *Courtesy of the Library of Congress.*

Opposite below: The main floor house interior has extensive hand-carved trim work and mantels, as seen here in the window entablature and room cornice. The second floor, interestingly enough, lacked this great woodwork and attention to detail. *Courtesy of the Library of Congress.*

LOCH DHU PLANTATION

The Kirk family, a prominent early South Carolina family in St. John's Parish, settled the Loch Dhu Plantation, formerly called Old Field. Robert James Kirk was born at Old Field in 1786 in a home that preceded the Loch Dhu house.

The property was located along a stream that the family dammed to form a small pond. The pond was used to power a mill on the property. The pond was a favorite place for the Kirk sons to swim and gig fish at night. The plantation was named for this small dark pond located on the property. Loch Dhu is a Gaelic term meaning "black lake."

Kirk built the Loch Dhu house between 1812 and 1816. The plantation later passed to Kirk's son, Philip C. Kirk, who continued the successful cotton cultivation of the property. Philip planted cotton, but added Indian corn and sweet potatoes. While owner of Loch Dhu, Kirk also served in the South Carolina State Legislature.

Philip's son, Robert, raised in a family with a tradition of public service, served as probate judge for Berkeley County from 1885 to 1893. In 1894, he accepted an appointment as U.S. consul in Copenhagen. He returned to Berkeley County in 1897 to continue his law practice.

During the War Between the States, Dr. Philip Sidney Kirk served as a surgeon in the Confederate army. Loch Dhu Plantation was used to nurse wounded Confederate soldiers. When General Hartwell's Union troops were raiding throughout St. John's Parish, they arrived with the intent of burning the plantation house and all the outbuildings. When the raiders arrived, the Kirk family women simply refused to leave the house. Not wanting to forcibly remove the women, the house was spared.

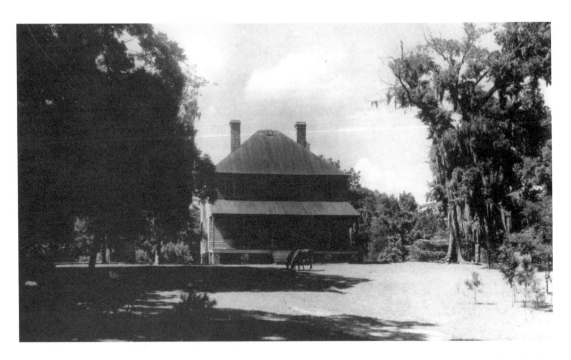

Loch Dhu is an excellent example of a popular St. John's design, with a square floor plan, high-hipped roof, tall chimneys and double front doors.

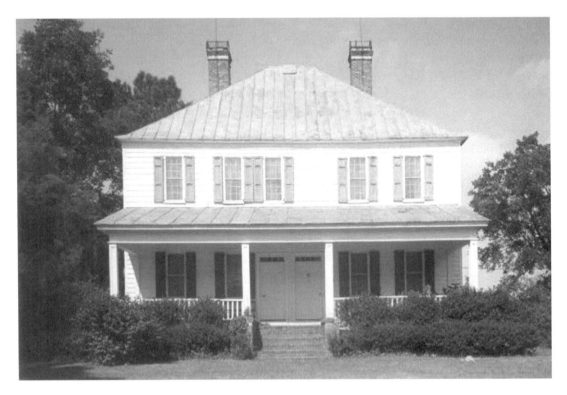

This picture features the Loch Dhu house after a restoration. While the plantation lands were flooded, the plantation house, built on high ground, was almost surrounded by the lake. The Loch Dhu fountains, lake and mill dam were lost.

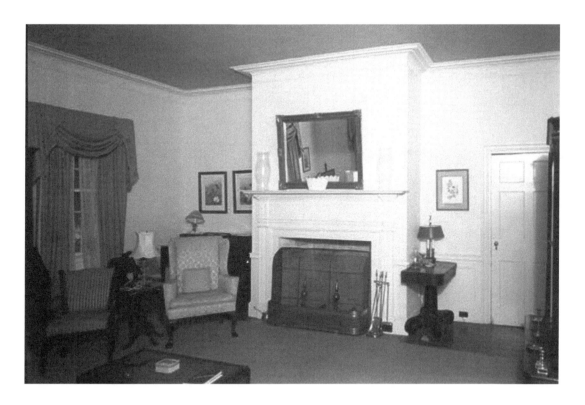

Above: This drawing room is located in the southwest corner of the first floor. Only the dining room and drawing room had hand-carved decorative trim. *Courtesy of the Library of Congress.*

Right: The house plan was typical of the region, featuring two front doors, one opening to the drawing room and the other opening to the dining room. The dining room featured stained woodwork, while the trim in the drawing room was painted.

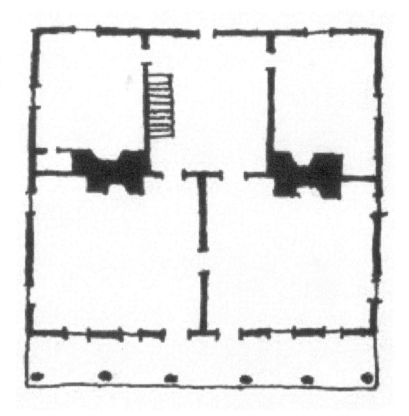

Left: The smokehouse survived the flooding for the lake. In 1977, it was placed on the National Register of Historic Places. *Courtesy of the Library of Congress.*

Below: The barn was also placed on the National Register of Historic Places, as was the plantation house. *Courtesy of the Library of Congress.*

NORTH HAMPTON PLANTATION

The St. John's property, later named North Hampton, was first acquired by Peter, the oldest son of Huguenot immigrant Pierre de St. Julien de Malacare, around 1700. He passed the property to his son Benjamin, who built the plantation house in 1716. Benjamin died without issue and the plantation returned to Peter. He then left the property to his sister Elizabeth, the wife of General William Moultrie.

As the Revolutionary War began, Moultrie was appointed to the rank of colonel in the Second South Carolina Regiment. In 1776, he was appointed second-in-command of the Charleston defenses. In January, he was assigned the task of building Fort Sullivan, later renamed Fort Moultrie. With no stone to construct a proper fortification, Moultrie chose to use palmetto logs to build his defenses.

The British fleet arrived at Charleston Harbor on June 4. On June 28, the British fleet initiated their bombardment of Fort Sullivan. Thanks to the spongy palmetto logs, the fort absorbed the cannon shot unharmed. After several ships ran aground and others were badly damaged by the Fort Sullivan guns, the British fleet withdrew in defeat that same evening. The great victory bolstered the hopes of the Patriots across the colonies and Moultrie became a national hero, rising to the rank of major general.

During the Revolution, the British controlled much of St. John's Parish. At North Hampton, like many of the region's plantations, the British seized the food provisions on the property, confiscated the horses, slaughtered the cattle and pressed the slaves into service. When Moultrie made his way back to North Hampton after the war, he commented that the only things he found left alive at his plantation were buzzards.

Moultrie became a leader in the efforts to build the first Santee Canal that would connect Columbia by water to Charleston, serving as president of the company responsible for the construction. With the canal finally complete in 1800, Moultrie hosted a celebration breakfast at North Hampton to honor Major Senf, the engineer in charge of the project.

The retired general enjoyed a profitable living planting indigo at North Hampton. After the Revolution, England no longer paid a bounty for indigo, destroying the once lucrative market. Moultrie, along with Captain Peter Gaillard of the Rocks and Captain James Sinkler at Belvidere Plantation, was one of the first St. John's planters to turn to cotton. He attempted his first crop in 1793, planting 150 acres. His yield the first year was only nine pounds of cotton

per acre. Within five years, North Hampton was producing a handsome profit with yields of over two hundred pounds per acre.

Moultrie's son inherited the plantation after his father's death in 1805, but he died young and unmarried. North Hampton was sold, passing through several families. Subsequent owners included Theodore S. DuBose; Henry W. Ravenel, son of Dr. Henry W. Ravenel of Pooshee; and Henry Le Noble Stevens, a nephew of Dr. Ravenel. At the height of operation just before the War Between the States, Stevens had 125 slaves working the plantation.

The upper story of the North Hampton house burned in 1842, and was soon restored. In 1939, North Hampton Plantation and several adjoining properties were owned by A.M. Barnes and Clarence Dillon of New York and used as a hunting preserve. These properties were highly regarded for the plentiful quail, turkey and deer inhabiting the preserve.

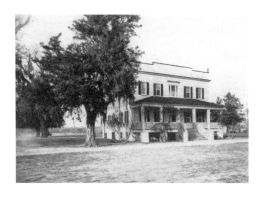

The North Hampton house was a square building, two stories tall, built of brick on the basement and first floor. In 1939, the house was in good repair and was surrounded by the plantation's outbuildings.

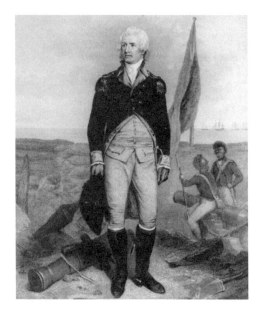

A Revolutionary War hero, General Moultrie continued in service to his state, with elections to the House of Representatives, the State Senate, as lieutenant governor and two terms as governor. He retired from public life in 1794. *Author's collection.*

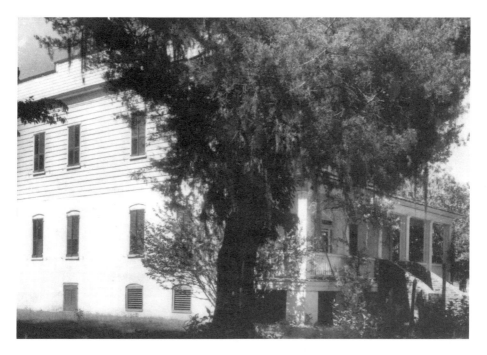

The North Hampton house and plantation complex were all destroyed. The property that was once home to one of South Carolina's greatest heroes is now under the waters of the lake.

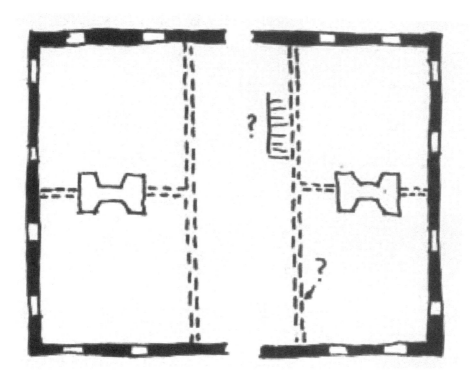

The North Hampton design utilized the familiar central hall flanked by rooms, front and back. The house included two large chimneys open to both the front and rear rooms.

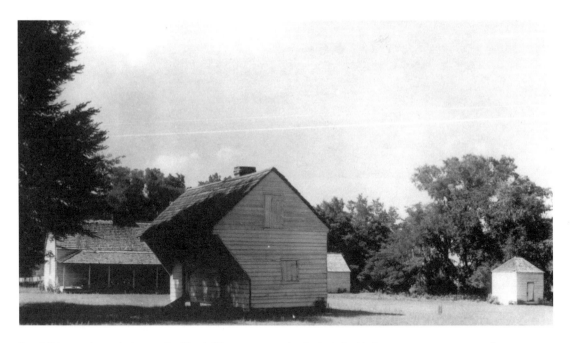

In addition to the main house, the North Hampton complex included a kitchen, two guest cottages, slave quarters, a smokehouse, barn and work shed. The outbuildings were all neatly whitewashed and had hand-split wooden shingle roofs.

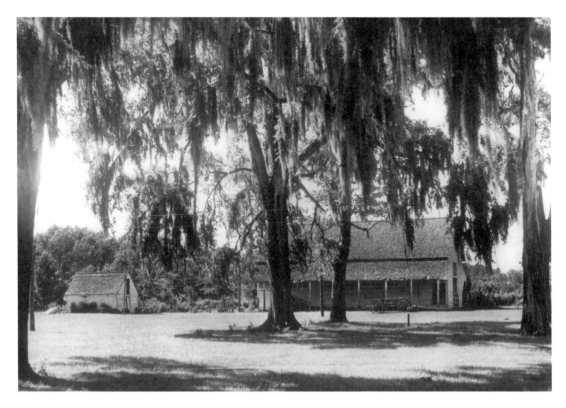

The large stable at North Hampton was once home to many fine horses raised and bred by the Moultrie and Ravenel families. In 1939, the stable was in fine condition, but empty.

OPHIR PLANTATION

Six miles northwest of Pinopolis was one of the ancestral homes of the Porcher family. Peter Porcher of Peru Plantation first acquired Ophir prior to the Revolutionary War. On his death, Peter left his three plantations—Peru, Mexico and Ophir—to his three sons.

Colonel Thomas Porcher, second born, inherited Ophir and built the plantation home in 1816. Thomas was almost singularly responsible for the rapid growth of the Porcher family name in St. John's, fathering 24 children. Colonel Porcher served as a state senator and an officer in the South Carolina militia. He died in 1836, leaving his sons and wife, Elizabeth Sinkler Porcher, to manage the plantation and its 140 slaves.

The plantation complex had all of the typical outbuildings, but also included a large church built on the grounds for the Porcher slaves. Behind the complex, the grounds featured two canals that fed into Ferguson's Swamp. These canals were used to power a mill at Ophir.

In 1939, Ophir was owned by a Porcher descendant, Henry F. Porcher, who was living in Memphis. Ophir ownership never passed out of the Porcher family. Henry leased the property to members of the Yeamon's Hall Club for use as a hunting preserve. The plantation house and grounds were in excellent condition. The plantation house and outbuildings were all destroyed to prepare for the flooding of the lake. The entire Ophir property was left beneath the waters of Lake Moultrie.

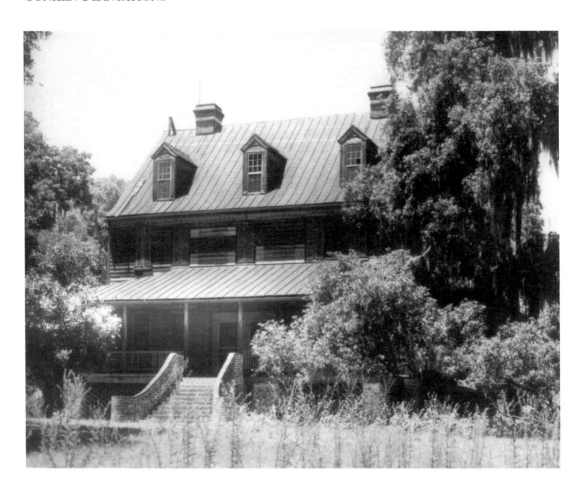

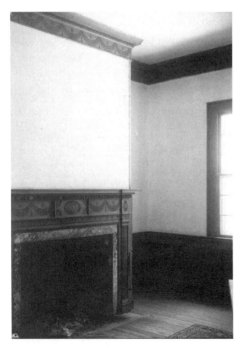

Above: The Ophir house was four stories tall, including the basement and attic, built of hand-hewn lumber. The exterior was covered in cypress weatherboards.

Left: The interior of the Ophir house featured elaborate hand-carved woodwork throughout. Waterman, in his survey, noted that the mantels in the front twin parlors "are the best examples of gouged and carved work in the area." *Courtesy of the Library of Congress.*

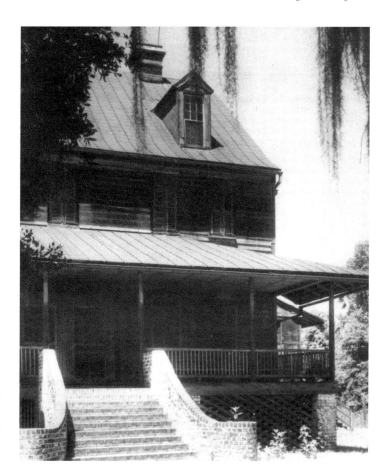

The Ophir house was described by Waterman as "large scale…rather barn like in effect." Affording great access to light, the house design allowed for sixteen windows.

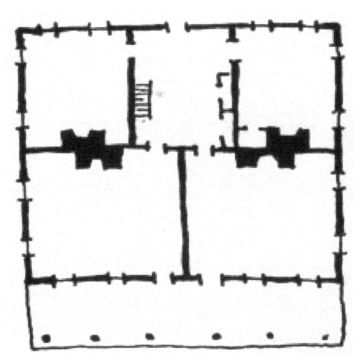

Though the Ophir house was located in the Pinopolis area, the floor plan was similar to the homes on the Santee, featuring double front doors opening to two rooms.

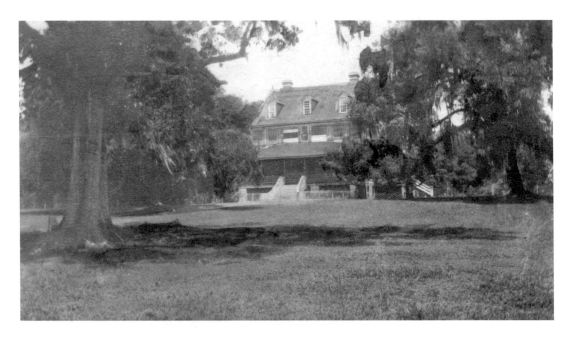

This picture of the Ophir house was colorized and reproduced on a postcard by the Porcher family for use as invitations and personal notes. *Courtesy of Mrs. Sarah Spruill.*

POND BLUFF PLANTATION

Pond Bluff earned its name from a pond located on the property, which is set on a bluff on the Santee Swamp. Located four miles east of Eutaw Springs, the property was first granted to James Flud in 1758. After several subsequent transfers, the plantation was sold to Francis Marion in 1773, who built the first home on the property.

Marion served as a captain in the Second South Carolina Regiment under William Moultrie at the Battle of Fort Sullivan. In 1776, he was commissioned as a lieutenant colonel in the Continental army. He later was appointed to the rank of brigadier general in the South Carolina militia. In the Southern campaign, Marion is credited with the effective use of guerilla tactics to deter and defeat the British army, which was clearly a superior force in numbers.

Pond Bluff adjoined lands owned by Marion's cousin and future wife, Miss Mary Videau. Marion and Miss Videau married late in their lives after the Revolutionary War. Both Marion and his wife adopted an heir. Marion adopted his grandnephew, Francis Marion Dwight, as his son and Mary adopted her husband's grandniece, Videau Ashby, as her daughter.

Marion died in 1795, leaving Pond Bluff to his wife with the provision that on her death Pond Bluff would pass to Francis Marion Dwight on the condition that he drop his surname and become the namesake of the general. Marion's will, though, was not properly executed and was therefore invalid. Mary Marion bought out the heirs of her husband to take sole title to Pond Bluff.

She died in 1815 and in her will divided the interest in the plantation between the daughter of her adopted heir and Colonel Keating Lewis Simons, a longtime friend and attorney. The Pond Bluff house burned and was destroyed in 1816.

Between 1825 and 1830, another house was built at Pond Bluff for Annie Cleland Simons, the widow of Colonel Simons. In 1939, Pond Bluff was home to her descendants, Joseph Palmer Simons and his sister, Miss Julia Simons.

Joseph Simons refused to willingly sell Pond Bluff to Santee Cooper. Santee Cooper moved to seize the property, employing "eminent domain," but Simons fought the condemnation process. At every stage the courts ruled against the defendant, leaving Simons despondent with

his legal options exhausted. True to his word that he would never leave Pond Bluff, Simons entered his home for the last time on July 7, 1939, placed a handgun against his temple and ended his life. He was one of the last bodies to be interred at the Rocks cemetery, now an island in the middle of Lake Marion.

An old Native American village was originally located on the Pond Bluff property. When clearing the plantation property in preparation of flooding Lake Marion, a large burial urn was found at the site. This historic artifact was donated to the George Heye Foundation, now part of the National Museum of the American Indian.

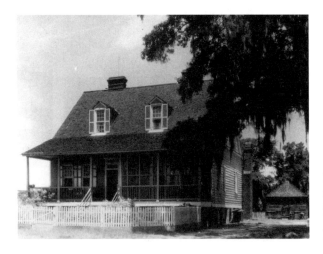

In his survey of St. John's homes, Waterman noted that Pond Bluff, newly painted and shaded by a massive live oak, was the smallest but perhaps the most attractive of the plantation homes in the region.

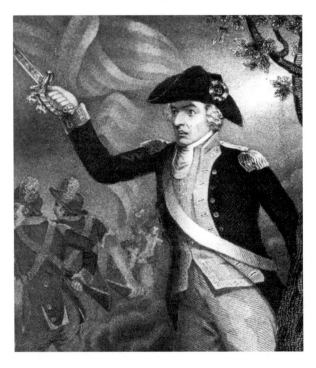

Francis Marion earned the moniker the "Swamp Fox" through his guerilla tactics, effectively harassing and frustrating the British army and Loyalists in the Southern campaign. *Author's collection.*

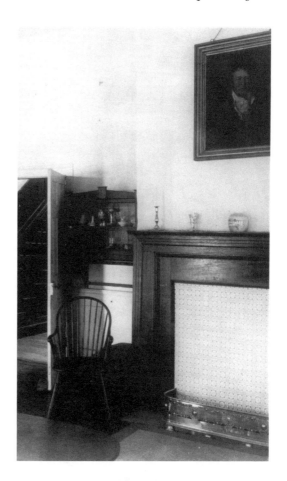

The interior of the Pond Bluff house was simple, though tastefully decorated. It did, however, lack the ornate carved cornices and woodwork common to St. John's Parish.

The Pond Bluff house was a one-story building, but the effective use of windows and dormers in the attic allowed for use of this level as well.

Left: The Pond Bluff house featured double front doors opening to two front rooms. Joseph and Julia Simons maintained an attractive home, as noted in this photograph.

Below: Pond Bluff was destroyed to make way for the lake. This property, once home to the great Swamp Fox, now sits below Lake Marion.

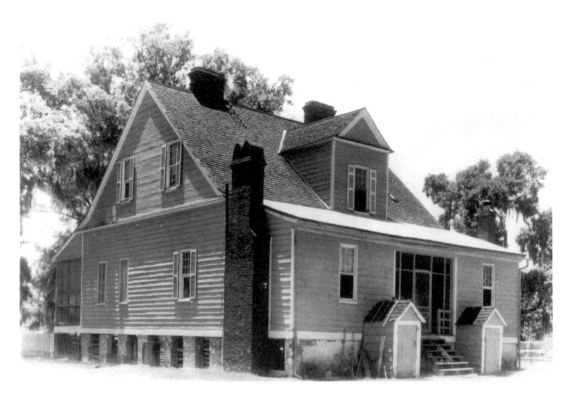

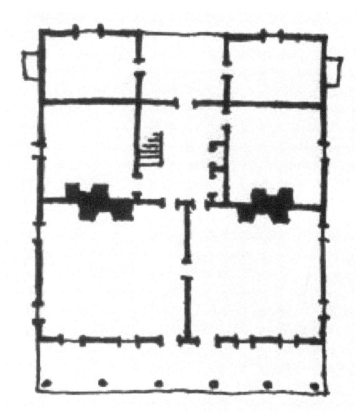

Right: The Pond Bluff floor plan was typical of the Santee homes. The house featured a covered porch at the end of the rear hall, flanked by two small rooms.

Below: Pictured are the smokehouse and kitchen for Pond Bluff Plantation. Note the interesting diagonally sheathed door. The door's hardware indicated a construction dating to Marion's occupation of the property.

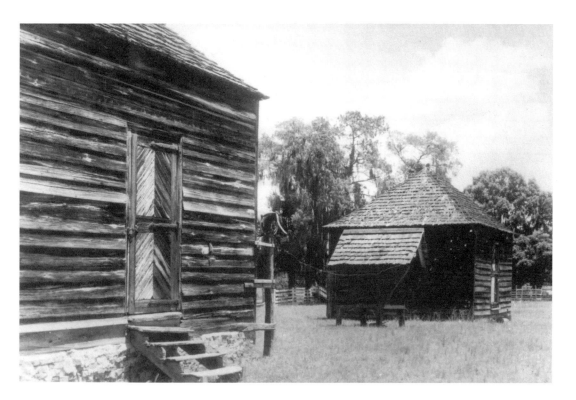

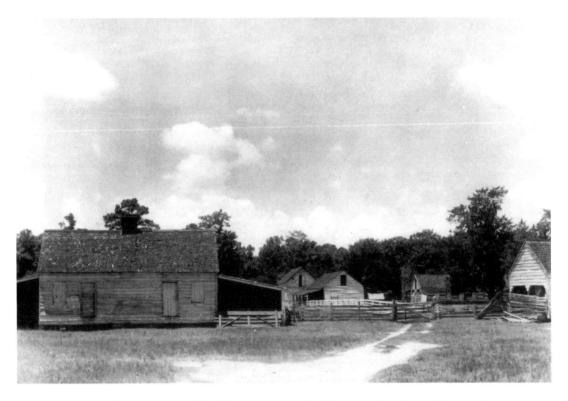

In 1939, Pond Bluff Plantation was still in full operation and the fields were all cultivated. Pictured here are the farm buildings supporting the plantation.

POOSHEE PLANTATION

In 1688, the Lords Proprietors granted Pierre de St. Julien de Malacare one thousand acres in Carolina that formed Wantoot Plantation. In 1705, St. Julien was granted an additional one thousand acres, forming the property known as Pooshee Plantation. Pooshee, like Wampee and Wantoot, is named for an early Native American settlement.

St. Julien sold the Pooshee property to his brother-in-law Henry Le Noble, who, in turn, deeded the property to his son-in-law, Rene Louis Ravenel. It was Ravenel who built the first house at Pooshee in 1716, though little is known about it or what happened to it. Ravenel cultivated indigo and rice on his St. John's plantation.

A second house was built in 1804 by a descendant who was also named Rene Ravenel. The property passed to Dr. Henry Ravenel, who added a curious wing to the western side of the house. It was under Dr. Ravenel's management that the plantation earned a reputation as an efficient and profitable operation. Ravenel continued the rice cultivation started at Pooshee in the eighteenth century. He added Santee long-staple cotton, further enhancing the profitability of his plantation. The plantation was entirely self-sufficient, growing vegetables to feed the family and slaves and producing cotton and wool to produce clothes and blankets.

In July 1831, the *Southern Agriculturalist* noted that Pooshee was a model for other planters. J.D. Legare, the editor and author of the article, noted, "Under Dr. Ravenel's system, the productiveness of his lands had been doubled in the course of eleven years." Unlike other planters, Ravenel did not rotate his crops. Instead, he applied heavy applications of manure produced at Pooshee. In 1831 alone, he applied the equivalent of 4,448 carts of manure to his fields.

By the twentieth century, Pooshee Plantation had increased to four thousand acres. The oak allée to Pooshee is located only a few hundred yards from Black Oak Church and the original Santee Canal. In 1939, brothers P.R. and R.D. Porcher owned the plantation, though no one was living in the house. A large portion of the plantation was covered by the lake project, including the house site.

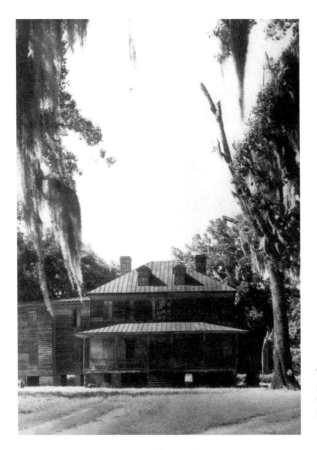

The 1939 Waterman report called Pooshee "the most forlorn ghost of a great past." By 1939, little would remind an observer of the great plantation that had been operated by Dr. Ravenel.

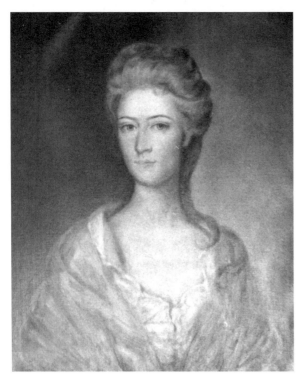

This portrait is of Susan, the daughter of Henry Le Noble and wife of Rene Louis Ravenel. She and her husband were the first to live at Pooshee.

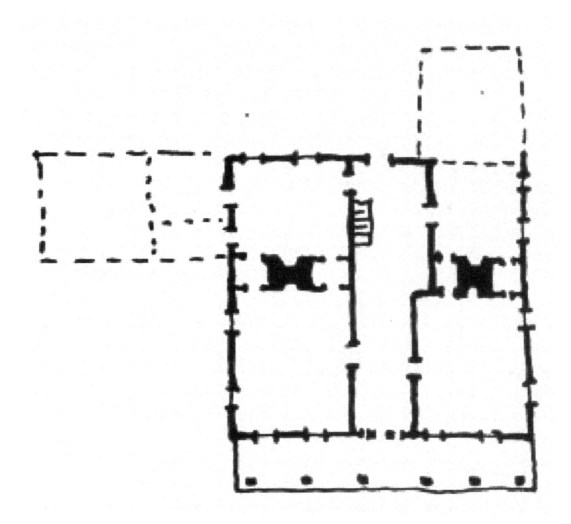

Waterman referred to Pooshee as "the fullest development of the central-hall type." The house was large in scale, with two full stories and a usable attic. By 1939, the house was damaged by fire and the interior trim was removed.

THE ROCKS PLANTATION

Captain Peter Gaillard, the son of a faithful Loyalist, determined to remain neutral when the Revolutionary War began. In 1781, Gaillard was placed second in command of a failed expedition organized by Lord Cornwallis to capture Francis Marion and his men. Gaillard later asked a boyhood friend to approach Marion in hopes that the Swamp Fox might allow him to join his militia, which he did.

After the war, Gaillard became a planter in St. Stephen's Parish. In 1794, he purchased the Rocks Plantation, initially to produce food for the slaves in St. Stephen's. The plantation earned its name from the limestone foundations there. Several limestone outcroppings were visible on the plantation property.

Gaillard was one of the founders of Pineville and maintained his residence in the small village. By 1805, he had built a home at the Rocks. Behind the house were two large ponds fed by limestone springs. Gaillard was the first in St. John's to experiment with cotton.

By 1828, Gaillard had made so much money in cotton he left his life as a planter to "retire" to Charleston. He provided a plantation property for each of his five sons and town homes for his three daughters. He died in Charleston in 1843.

He passed the Rocks to his son Samuel, an officer on the USS *Constitution*. Samuel later passed the plantation to his daughter Elizabeth, the wife of James Gaillard Jr. of Walnut Grove and a graduate of Princeton.

In 1868, Professor Frederick Porcher wrote of the Rocks, "This house was a model of elegance, neatness and comfort, and all the appointments executed with so much care and taste that the Rocks became a standard by which all other homesteads were judged."

The Gaillard family was known for its lavish Christmas celebrations where the extended family all gathered. Mrs. A.P. Leise Palmer Gaillard wrote a sketch of the Gaillard family and the Rocks in 1942 in which she reminisced about the Christmases past.

> *Christmas morning after breakfast, the dining room was put in order, the dining table stretched to its fullest extent and covered with one of the beautiful Irish damask tablecloths...At one end was a turkey stuffed with spinach...At the other end another turkey stuffed with the more usual*

bread crumbs. At various places along the table were a boiled ham, a large one, a huge roast of mutton, leg and loin, from four to six boiled chickens, big ones, with a very rich sauce with hard boiled eggs stirred up in it, dishes of snowy rice. In addition there were pans of macaroni, sweet potatoes, Irish potatoes, creamed artichokes sometimes, glass dishes of whole artichoke pickles, a decanter of whiskey and two or three decanters of wine. Then for dessert: Charlotte Russe, wine jelly and Syllabub, and always four kinds of pie—coconut, lemon, mince and sweet potato.

In 1907, the Rocks was sold to T.L. Connor, who later passed the plantation to his son, J. Rutledge Connor. In 1939, all the lands were still in full cultivation. The plantation would have been under as much as ten feet of water when flooded. To save the property, Connor moved the Rocks house seven-tenths of a mile to Belmont Plantation, another property he owned.

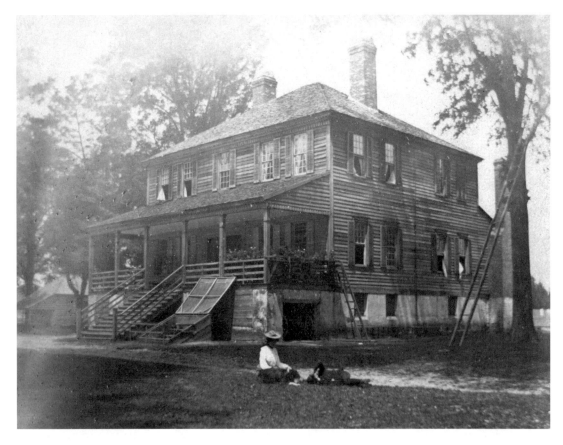

In 1939, Waterman reported, "The Rocks should be the culmination of the architectural development of the region, as its suave design and beautiful detail place it as the finest of the group." *Courtesy of Mrs. Sarah Spruill.*

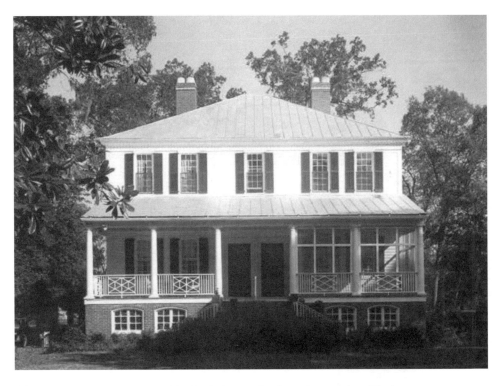

J. Rutledge Connor fully restored the Rocks house after he took possession. The house rests on a high, ground-level brick basement.

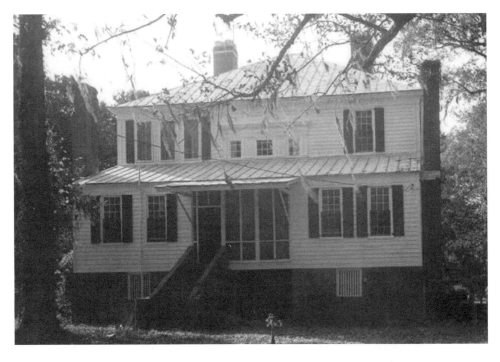

The house was well maintained and in excellent condition. Like Pond Bluff, the Rocks house features a rear-covered porch flanked by two small rooms.

The interior of the Rocks house maintained the original woodwork and hand-carved cornices, which had been perfectly restored. *Courtesy of the Library of Congress.*

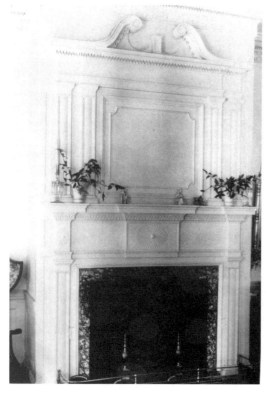

Left: The mantels throughout the Rock were exceptional. Gaillard's daybook, which has survived, identifies the mantels as being shipped in from the North. The design and craftsmanship suggest they may have been made in Rhode Island.

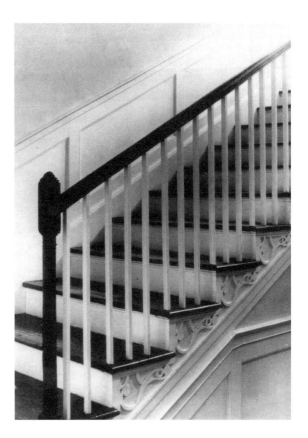

Even the stairway received the same meticulous attention as the rest of the interior, making the Rocks a grand showplace.

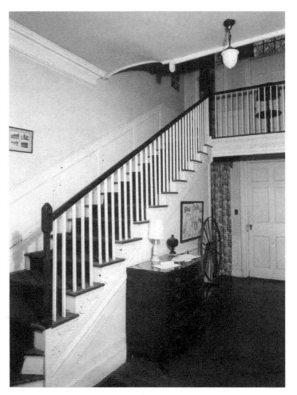

As with the other first-floor rooms, the stair hall reflected the refinement of the house. *Courtesy of the Library of Congress.*

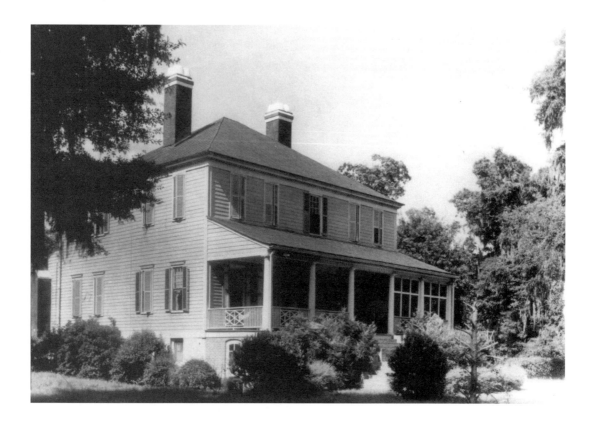

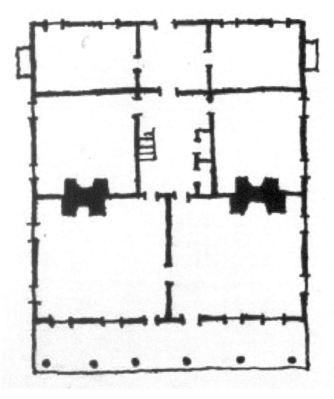

Above: The Rocks house was placed on the National Register of Historic Places in 1977. Unfortunately, the house was destroyed by fire in 1992.

Left: The Rocks Plantation house was similar in design to the Pond Bluff house, though much larger in scale. Professor Porcher noted in 1868, "It was possible to equal The Rocks, to surpass it was impossible."

SOMERSET PLANTATION

Prior to the Santee Cooper Project, Somerset Plantation could be found just two miles from Pinopolis. The origin of property ownership can be traced back to a grant conveyed to John Stewart in 1696. Soon thereafter, Stewart conveyed his property to Reverend William Screven, thought to be the first Baptist preacher to settle in Carolina. Screven hoped to establish a Baptist settlement in St. John's Parish. However, it did not materialize and in 1704, Screven sold his property, now totaling 1,100 acres, to Rene Ravenel.

In 1736, Ravenel divided his property, conveying 725 acres named Somerset to his brother Daniel. In the following years, Somerset sold through many owners until Isaac M. Dwight and William Cain purchased it in 1827. They divided the property and Cain took title to the portion with the plantation house, which he remodeled in 1854.

Cain was an influential man across the state, serving in the state legislature, as South Carolina's delegate to the Electoral College and as lieutenant governor. As South Carolina debated its exit from the Union, Cain was a signer of the Ordinance of Secession.

In an address before the St. John's Hunting Club in 1907, Reverend Dr. Robert Wilson spoke of Cain, describing him as "tall of stature, dignified in presence and deliberate in all his movements, Mr. Cain exhibited to all a gentle courtesy and polished address which testified conclusively that these traits were not the exclusive heritage of pure Huguenot descent…Cain was a successful planter of long cotton and his crops usually brought the top of the market."

Cain enjoyed a great reputation for his Santee long-staple cotton. He developed a habit of baling his cotton in round bales and marking them with his initials to ensure the brokers would find his cotton at auction. On one trip to Paris, Cain was excited to find his round bales arriving in the French capital.

The plantation remained in the Cain family until Santee Cooper acquired it. The property was cultivated until the family was forced to leave. The heirs of Dr. Joseph P. Cain, who held title to the property, dismantled the house before the flood.

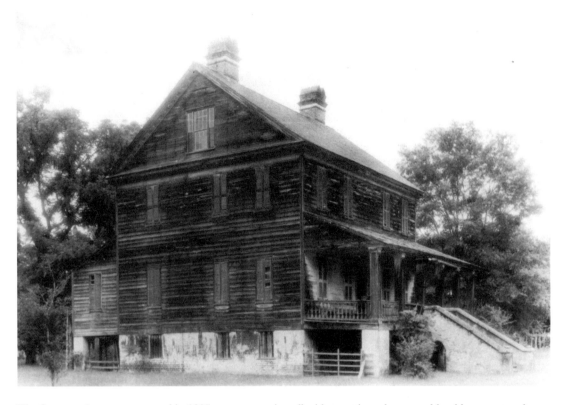

The Somerset house, constructed in 1827, was two stories tall with an attic and a ground-level basement and was covered with unpainted cypress weatherboards.

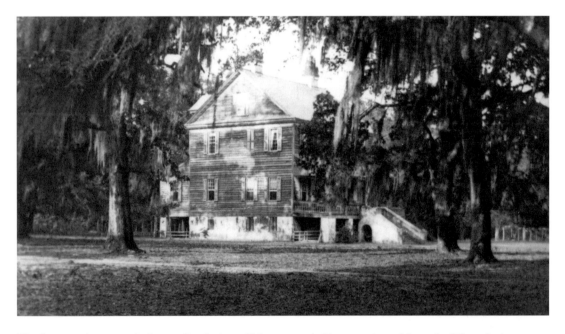

The Somerset house was built on a flat site beautifully surrounded by moss-draped live oaks. When the house was remodeled in 1852, Cain enhanced the mantels and doors and made changes to the porch columns. *Courtesy of Mrs. Sarah Spruill.*

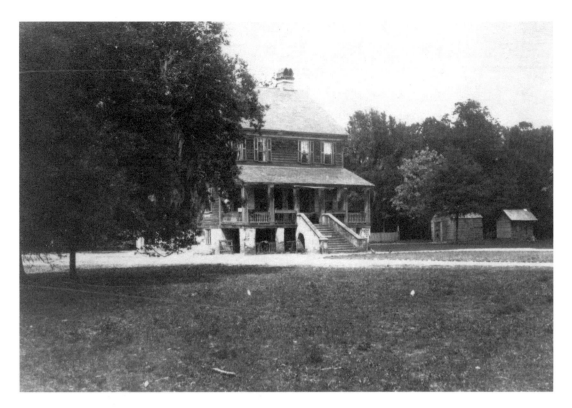

When acquired by Santee Cooper, Somerset still had the full complement of outbuildings and farm buildings. These structures were destroyed along with the house. *Courtesy of Mrs. Sarah Spruill.*

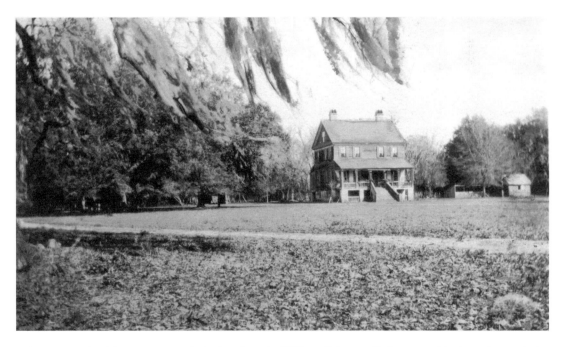

This photograph of Somerset was colorized and sent by William Cain as a Christmas card in the early twentieth century. *Courtesy of Mrs. Sarah Spruill.*

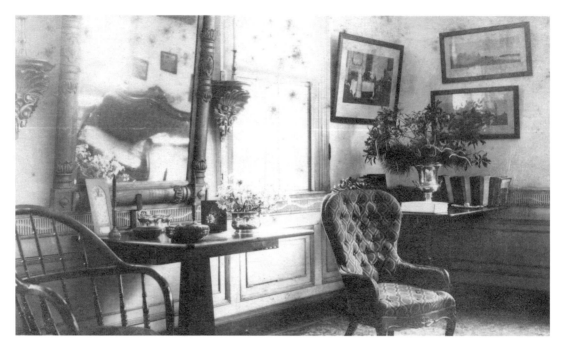

This view of the Somerset front parlor reflects the elegance with which the house was decorated. Actively living and working the plantation, the Cain family did not willingly leave Somerset. *Courtesy of Mrs. Sarah Spruill.*

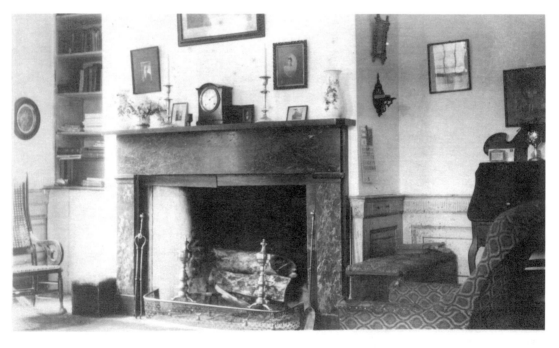

This mantel and fireplace in one of the front parlors is typical of the fine adornments in the Somerset house. The mantels in the front rooms were made of black and gold marble. *Courtesy of Mrs. Sarah Spruill.*

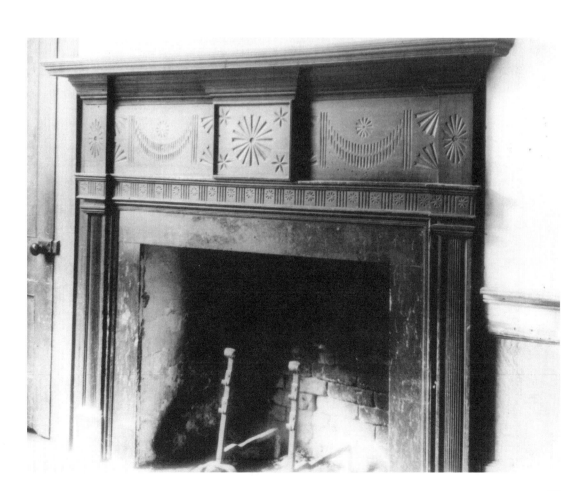

Right: This photograph is of the southeast room on the main floor of the Somerset house. The portrait hanging between the windows is of Henrietta Gourdin Ravenel Gaillard, born in 1816. Her daughter by her first marriage wed Charles Macbeth. Two of the Macbeth daughters married sons of William Cain.

Below: This mantel, located in the northeast room of the first floor of the Somerset house, is also made of black and gold marble. The intricate hand carvings are thought to have been original to the house.

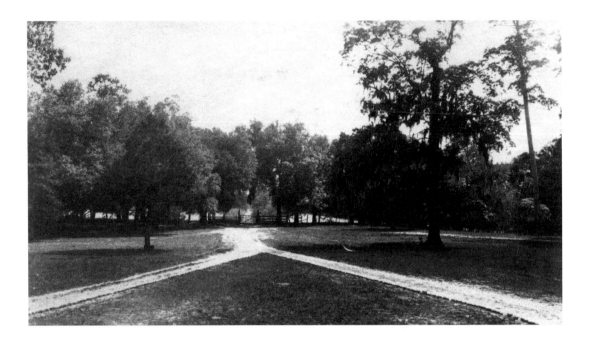

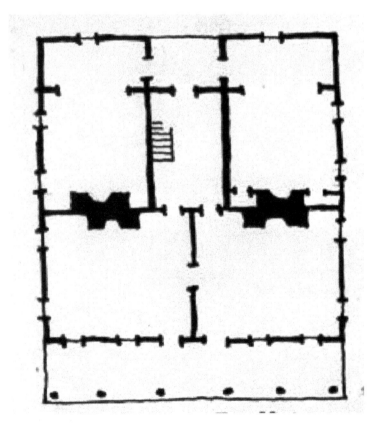

Above: This view of Somerset Plantation is from the front porch of the house. *Courtesy of Mrs. Sarah Spruill.*

Left: The floor plan is similar to other plantation homes in the Santee group, including Belvidere, Pond Bluff and the Rocks, with the double front doors and central hall only in the rear of the house.

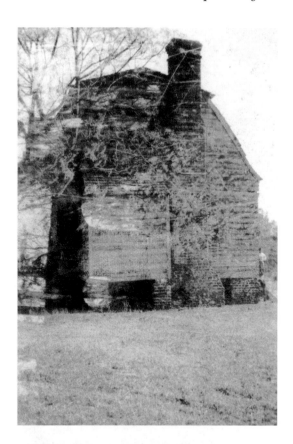

This photograph is of the Somerset kitchen located off the rear of the main house. The kitchen building was a simple construction, built with cypress weatherboards. *Courtesy of Mrs. Sarah Spruill.*

Pictured is William Cain (1874–1926), son of Dr. Joseph Palmer Cain. He was the last family member to farm the land at Somerset. *Courtesy of Mrs. Sarah Spruill.*

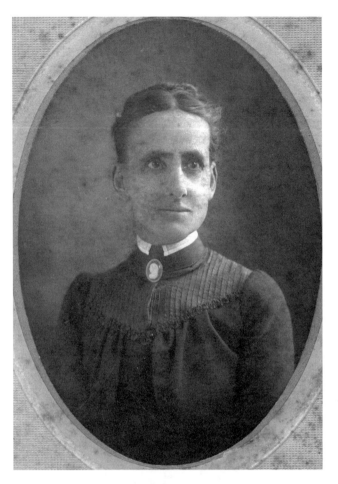

Left: Pictured is Mrs. Mary Macbeth Cain (1851–1926), the wife of Dr. Joseph Palmer Cain. *Courtesy of Mrs. Sarah Spruill.*

Below: In this photograph, circa 1920, the Cain family poses on the front steps of the Somerset house. *Courtesy of Mrs. Sarah Spruill.*

A drought in 1954 brought the level of the lakes down to the lowest point since the flood. The remnants of many of the destroyed plantations were now exposed. Here the Cain family poses on the ruins of the steps of their once proud Somerset Plantation home. *Courtesy of Mrs. Sarah Spruill.*

SPRINGFIELD PLANTATION

Isaac Couturier and Thomas Palmer acquired a grant for property in St. John's Parish. Shortly before the Revolution, Captain John Palmer purchased this property, which he named Springfield. He never lived at Springfield, preferring to reside at Richmond Plantation, his St. Stephen's property. Captain Palmer did cultivate Springfield, planting indigo and, later, cotton.

During the Revolution, Captain Palmer served as an aide to General Francis Marion. He survived the war and in 1794 was one of the founders of Pineville. He was active in St. Stephen's Parish and is credited with writing the historical sketch of the parish for Ramsey's *History of South Carolina*, published in 1809.

Captain Palmer died in 1817 and Springfield passed to his son Joseph. In 1801, Joseph had married Elizabeth Catherine Porcher, the daughter of Peter Porcher of Peru Plantation. After Joseph acquired the St. John's property, he decided to live at Springfield and hired George Champlin to build his home. Using slave craftsmen from other plantations, the Springfield house was completed in 1818.

Joseph was highly regarded in St. John's Parish. Professor Frederick Porcher writes of Joseph in 1868, "Few persons have ever had so many trusts confided to them as executors; and none has ever discharged them more assiduously or more faithfully." A spirited family man, Joseph and Elizabeth had fourteen children.

In an article titled "Upper Beat of St. John's Parish," Professor Porcher writes, "The splendid mansion on the Springfield Tract was the abode of the most liberal and unostentatious hospitality. At a time when the roads were thronged with travelers, his house, which was conspicuous from the road, attracted strangers as well as friends, and all were considered equally entitled to its sacred rites." Porcher writes of the property, "The land thereabouts [Springfield] is some of the finest in South Carolina, and very congenial to the growth of long staple cotton."

Joseph died in 1841 and bequeathed Springfield Plantation to his eleventh child, also named Joseph, born in 1818. He did leave the use of Springfield to his wife as long as she lived or remained his widow. Elizabeth died just two months later.

Joseph, the son, graduated from South Carolina College and the Medical University of South Carolina and was a practicing physician in St. John's Parish. Dr. Palmer lived at the Rocks with his sister Henrietta and used the Springfield mansion as his medical office.

As war came to South Carolina in 1861, Dr. Palmer was too old to serve and he remained in St. John's to practice medicine. In 1864, he married Margaret Allen of Richmond, Virginia, and the couple made Springfield their home. Through the war, Dr. Palmer donated all the cotton harvested on his plantation to the Confederacy.

General Hartwell's Union troops, when sweeping through St. John's, raided Springfield Plantation. They took the property and provisions they desired. The flour, cornmeal and molasses were simply poured out into the dirt of the property. A trusted house slave, Maum Hagar, saved the family table silver. She placed the silver in a bag, tied it to her waist and hid it under her large skirt.

In 1897, Edmund Palmer, Dr. Palmer's son, passed up his last year of school at Porter Academy in Charleston to remain at Springfield and take charge of the plantation for his elderly father. He restored the neglected fields and the dilapidated outbuildings on the property. In addition to planting the fields, he also brought Jersey and Angus cattle, sheep and hogs to Springfield.

After the death of his father in 1905, Edmund purchased the interests of his siblings to become the sole owner of Springfield. The plantation never passed out of the Palmer family. When Santee Cooper acquired the property, Springfield was home to Edmund's widow and Mr. and Mrs. Thomas S. McGuinness, her daughter and son-in-law.

Leize Palmer Gaillard, Edmund's sister, writes, "How long will Springfield remain in its setting of oaks, sycamores, cedars, walnuts, holly and crepe myrtles—each with their long streamers of gray Spanish moss? Who can tell! Progress, the insatiable monster, demands that all that area of St. John's Berkeley, with its beautiful homes and historic associations, be submerged by the muddy waters of the Santee."

The Springfield house and plantation property, situated on low ground, was all destroyed to make way for the lake flooding.

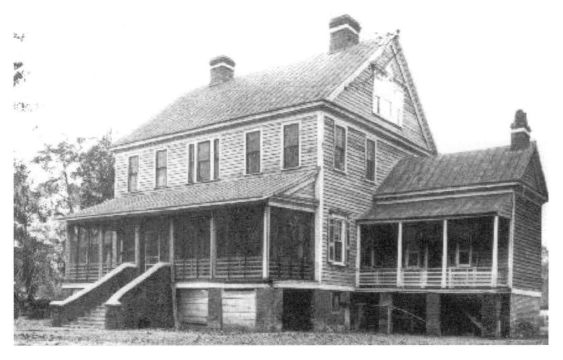

The Springfield house was two stories tall with a full ground-level basement. Waterman reported that the mansion "has none of the grace or refinement of The Rocks or Lawson Pond, though its trim exceeds in elaboration any other."

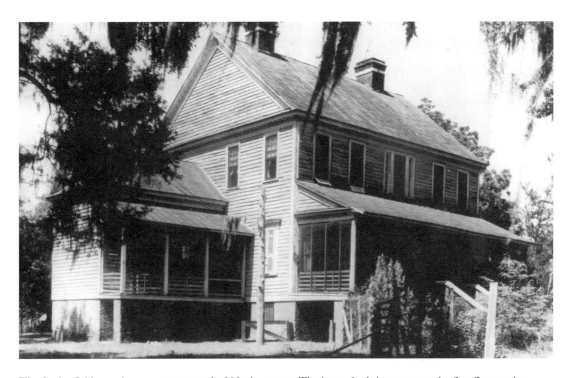

The Springfield mansion was constructed of black cypress. The house had six rooms on the first floor and a broad piazza stretched across the front.

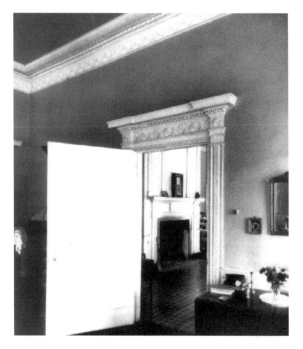

The Springfield house featured elaborate hand-carved trim throughout. One Palmer relative described the superb craftsmanship as "giving one the impression of something made of lace rather than of wood."

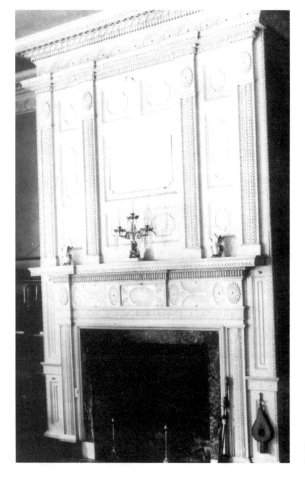

Both of the front rooms on the first floor of the Springfield house featured large and impressive mantels from the floor to the ceiling.

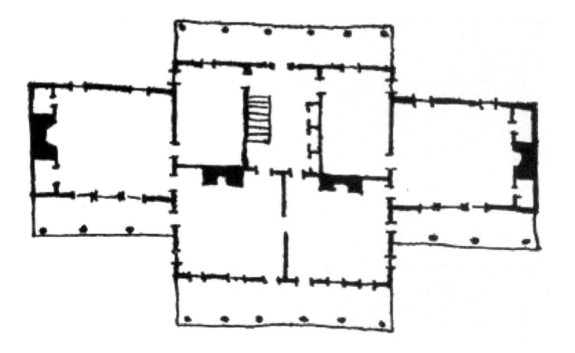

Above: The Springfield floor plan featured the familiar double front doors. The second-floor design called for a wide central hall, four large rooms and fourteen closets.

Right: When acquired by Santee Cooper, this large Dutch oven was found just behind the house at Springfield Plantation.

WAMPEE PLANTATION

In 1696, John Stewart received a grant from the Lords Proprietors for 804 acres known as Wampee, west of the Biggin Swamp. Part of this grant would later become lands for Somerset and Somerton Plantations.

In 1698, Reverend William Screven, a Baptist minister, acquired the Wampee tract from Stewart and by 1700 added a three-hundred-acre tract adjoining the property. Screven made Somerton Plantation his home.

Most residents of St. John's attended the Anglican Church and were wary of Screven's attempts to create a Baptist settlement. In 1703, Judge Nicholas Trott wrote the archbishop of Canterbury asking for Anglican literature, stating, "We are here very much infested with the sect of Anabaptists." Screven's ambition to create a Baptist settlement was not realized and he sold his property to Rene Ravenel.

By 1749, Gabriel Guignard had acquired Wampee, planting indigo and rice on the plantation. Over the next forty years the plantation passed through several families until Charles Johnson purchased it in 1790. The plantation passed to his daughter, who married James Macbeth. Their son Charles would later become the mayor of Charleston during the War Between the States.

James Macbeth died in 1822 and Charles built the current Wampee home for his mother in that same year, the third house built at Wampee. Charles's daughter later acquired the Wampee property and through marriage the plantation was passed to the Cain family.

Santee Cooper acquired the Wampee property through eminent domain. After the flood, the waters of Lake Moultrie covered the Wampee lands and left the house dry on the bank of the lake. Santee Cooper renovated the house to host visiting dignitaries.

The Cain family, angry that they were forced to sell Wampee but the house survived, filed a lawsuit against Santee Cooper pointing out that the acquisition of the Wampee house was not critical to the hydroelectric project. In 1945, the South Carolina Supreme Court agreed and returned the Wampee house to the Cain family.

Santee Cooper, determined to make use of Wampee, made an extremely lucrative offer to the family and, this time, bought the house and remaining land with the cooperation of the Cain family.

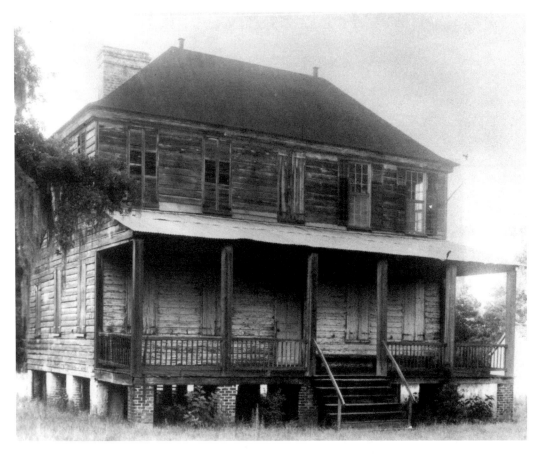

The Wampee house, located one mile from Pinopolis, is the only plantation house in middle St. John's Parish still standing on its original site of construction. Waterman noted that the house was reminiscent of houses in the British West Indies.

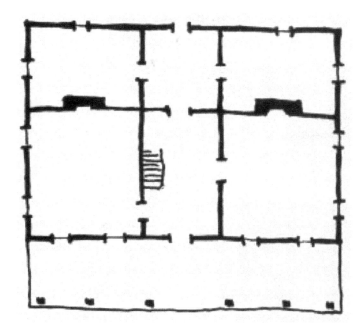

Right: The floor plan reflects the style common to the houses in the Pinopolis region, utilizing a central hall and four rooms on two levels. The house did feature a large piazza across the front of the house.

Below: In 1988, Santee Cooper established Wampee as a conference center overlooking Lake Moultrie. The Wampee site was home to several Native American burial mounds.

WHITE HALL PLANTATION

The grounds of White Hall Plantation were the site of a colonial-era tavern and inn on the Congaree Road. Located five miles northwest of Pinopolis, the plantation is thought to be named for an early owner, Blake Leay White, the commissioner for high roads in St. John's Parish in the 1770s.

Colonel Thomas Porcher, owner of neighboring Ophir Plantation, purchased White Hall and built the house for his son, Thomas. Thomas moved to White Hall joined by his bride, the daughter of Captain Peter Gaillard of the Rocks Plantation. Their daughter, Elizabeth, married Dr. Charles Lucas of Charleston and White Hall Plantation passed to the Lucas family. Prior to 1939, the plantation passed to the Cain family through marriage.

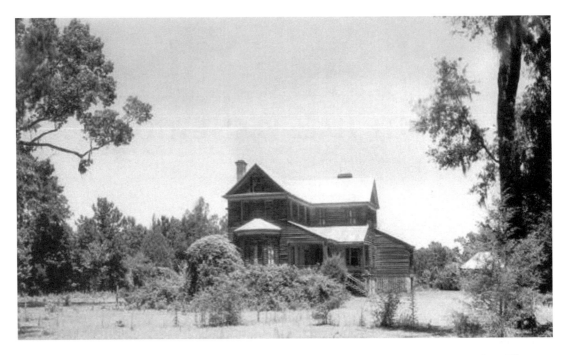

White Hall Plantation was located south of Ferguson Swamp, between Hanover and Ophir Plantations. The house was two stories tall with a gable roof.

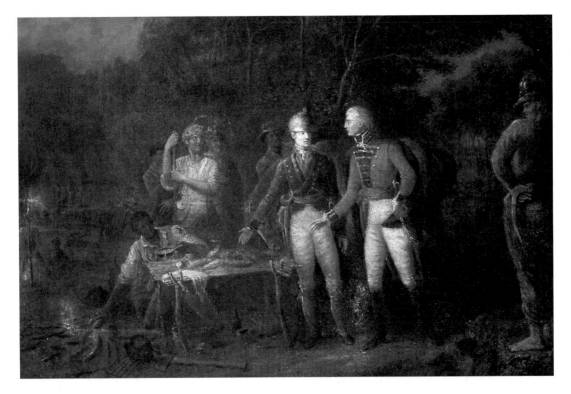

John Blake White, son of Blake Leay White, born at White Hall, was a prominent attorney and highly regarded painter. Four of his paintings, including this one of Francis Marion, hang in the U.S. Capitol. *Courtesy of the Collection of the U.S. Senate.*

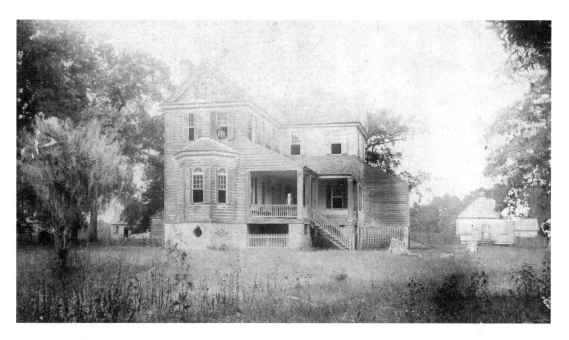

In 1854, Dr. Charles Lucas added a new wing and the piazza to the house. Lucas was careful to duplicate the fine detail of the original section when adding the new wing. A polygonal bay window was added to the end of the addition. *Courtesy of Mrs. Sarah Spruill.*

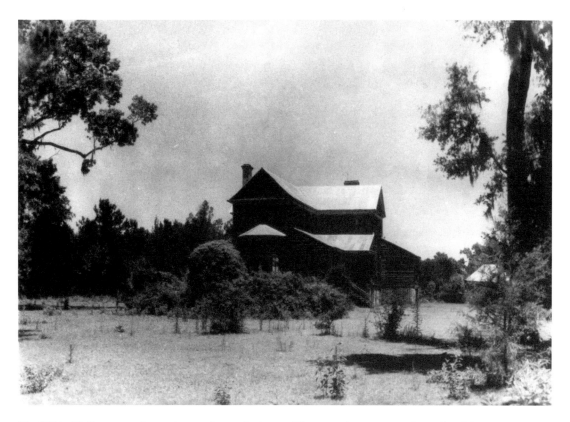

The White Hall property featured a pond near the house. The grounds were attractive and well kept.

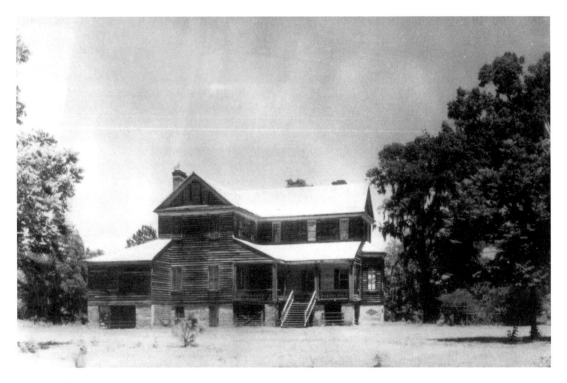

This view of the White Hall house from the front clearly shows the addition on the left side.

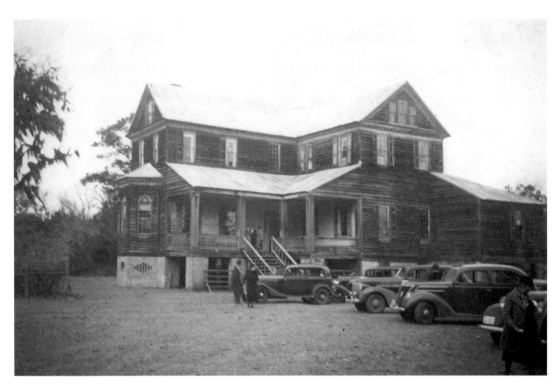

This photograph was taken while White Hall was hosting a meeting of the St. John's Hunting Club. *Courtesy of Mrs. Sarah Spruill.*

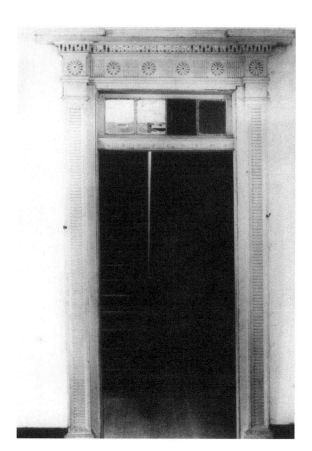

The White Hall front doors were more decorative than most plantation homes. The front doors never had locks, which was certainly a feature of a different era.

The entrance hall of White Hall Plantation clearly reminds the visitor of the great affinity the family had for hunting, perhaps only matched by their enthusiasm for horses and racing.

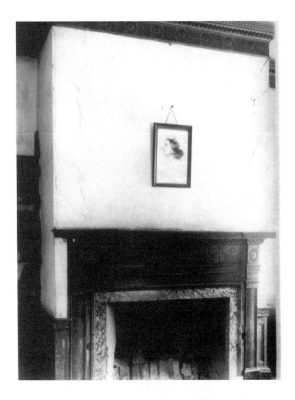

The dining room of White Hall was known for having the finest woodwork in the parish, thought to have been carved by the same craftsmen executing the great woodwork at Ophir. The fireplace facing is made of Pennsylvania blue marble.

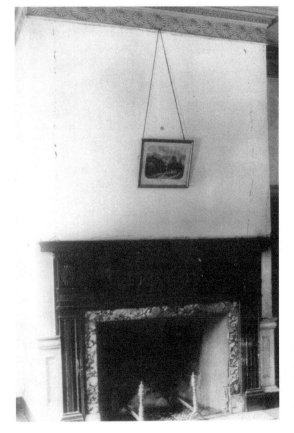

The Cain family dismantled the woodwork and mantels before surrendering the house to the Santee Cooper Project. Many years later the dining room woodwork and mantels were purchased, and they are displayed at the Museum of Southern Decorative Arts in Old Salem, North Carolina.

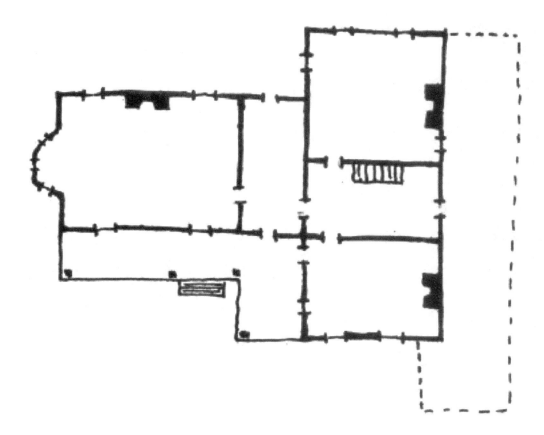

Above: The floor indicates the traditional double front doors of the Pinopolis region. The 1854 addition to the house was used as a ballroom for entertaining.

Right: This photograph is of Lewis Lucas of White Hall Plantation preparing to leave for hunting. Lucas is mounted aboard Manila, a horse he trained for the hunt. Accompanying Lucas was his hunting dog, Jack. *Courtesy of Mrs. Sarah Spruill.*

This photograph is of Henry Ravenel Lucas at White Hall Plantation preparing for a ride. Henry was the son of Lewis and Florence Lucas. *Courtesy of Mrs. Sarah Spruill.*

WOODLAWN PLANTATION

The first records of Woodlawn Plantation indicate Edward Edwards was the owner. When he acquired the property or how long he may have owned it is unknown. Edwards sold the plantation to Stephen G. Deveaux, a master builder. Deveaux had inherited Belle Isle Plantation from his stepfather, Robert Marion, the nephew of General Francis Marion.

The property sits on the boundary between St. John's and St. Stephen's Parishes. In fact, the main house is in St. John's, yet the kitchen is in St. Stephen's. Deveaux built the plantation house prior to 1810. He was determined to build a plantation to outshine Belle Isle. Even when he completed the magnificent main house, he could not rest. Deveaux then started on the outbuildings. Every one was built with the greatest care and everything had to be in balance. When he built a smokehouse on one side, he then placed the meat house on the other side of the house. The grounds featured an impressive oak allée leading to Black Oak Church.

Deveaux died in 1850 and Woodlawn passed to his son, Stephen L. Deveaux, who sold Woodlawn to Dr. Henry Ravenel. Other than Wantoot, which he could not acquire, this acquisition gave Ravenel adjoining plantations stretching fourteen miles along Black Oak Road.

Dr. Ravenel passed Woodlawn Plantation to his son William. Many young nephews of William Ravenel would spend the winters in the guest lodge at Woodlawn to attend Pineville Academy, five miles away. After he died, his heirs sold the property to Percival Ravenel Porcher.

In 1939, the owner of Woodlawn was Clarence P. Gourdin, having purchased the property from Porcher. Gourdin would often comment that Woodlawn was the finest house between the Santee and Cooper Rivers. There were few who would dispute him. When Santee Cooper acquired the property, the house was uninhabited and was slipping into ruin. The plantation grounds were flooded by the hydroelectric project. The Woodlawn house was moved to Georgetown, South Carolina, and reconstructed.

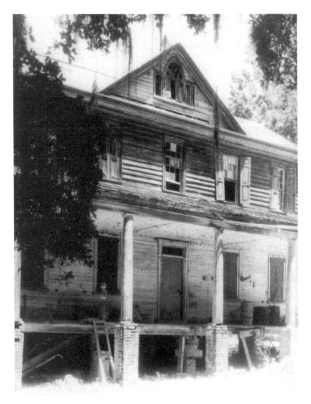

Left: The Woodlawn house, constructed of heart pine, had seventeen rooms, plus sundry storerooms and closets. Waterman reported, "Most magnificent and most tragic of the great houses of the region is Woodlawn, vast, deserted and falling rapidly into complete decay."

Below: The porch columns were set beyond the line of the porch and, unlike others in St. John's, were mounted on brick piers. The roof, still in excellent condition, was made of small squares of English tin, hand crimped and soldered.

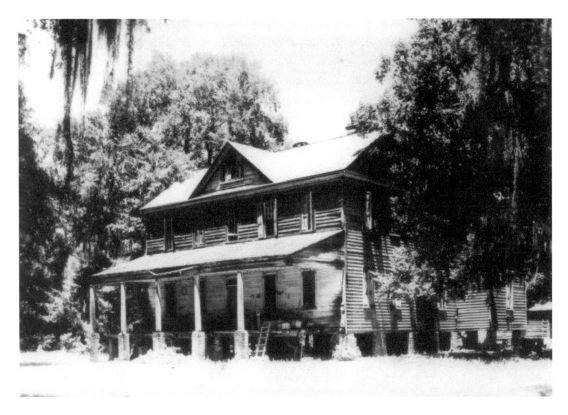

The interior of the Woodlawn house was tasteful, though simple. The mantels were made of black and gold Italian marble.

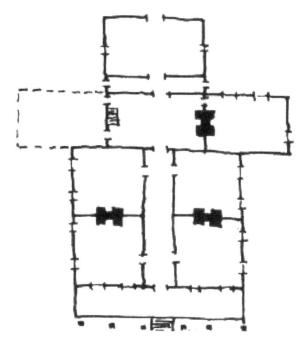

The floor plan was typical of the Pinopolis region, a central hall flanked by four rooms. The rear wings were an unusual feature.

BIBLIOGRAPHY

Berkeley County Historical Society. *Upper Parish, St. John's, Berkeley.* http://www.rootsweb.com.

Cross, J. Russell. *Historic Ramblin's Through Berkeley.* Columbia: R.L. Bryan Company, 1985.

Davidson, Chalmers G. *The Last Foray, The South Carolina Planters of 1860: A Sociological Study.* Columbia: University of South Carolina Press, 1971.

Edgar, Walter B. *History of Santee Cooper, 1934–1984.* Columbia: R.L. Bryan Company, 1984.

Fishburne, Anne Sinkler. *Belvidere.* Columbia: University of South Carolina Press, 1949.

Irving, John B., MD. *A Day on Cooper River.* Charleston: A.E. Miller, 1932.

LeClercq, Anne Sinkler Whaley. *An Antebellum Plantation Household.* Columbia: University of South Carolina Press, 2006.

News and Courier archives, Charleston, South Carolina.

Peter Gaillard Papers. South Carolina Historical Society, Charleston, SC.

Photograph archives. Santee Cooper, Moncks Corner, SC.

Porcher, Richard Dwight, and Sarah Fick. *The Story of Sea Island Cotton.* Charleston: Wyrick and Company, 2005.

Rocks Church of the Epiphany. Unpublished booklet.

Spruill, Sarah. *Re: Somerset Plantation.* E-mail to the author. January 28, 2008.

Walsh, Norman Sinkler. *Plantations, Pineland Villages, Pinopolis and Its People.* Virginia Beach: The Donning Company, 2006.

Waterman, Thomas T. *A Survey of the Early Buildings in the Region of the Proposed Santee and Pinopolis Reservoirs in S.C.* Washington, D.C.: U.S. Department of Interior, National Park Service, 1939.

Zeigler, John A., ed. *Picture Progress Story.* Charleston: Walker Evans & Cogswell Company, 1945.

ABOUT THE AUTHOR

Doug Bostick is an eighth-generation South Carolinian with ancestors dating back to colonial America. A gifted storyteller and historian, he is the author of four books: *Secession to Siege 1860/1865*, *On the Eve of the Charleston Renaissance*, *Memorializing Robert E. Lee* and *The Boathouse: Tales and Recipes From a Southern Kitchen*.

Bostick is a graduate of the College of Charleston and earned a master's degree from the University of South Carolina.

Visit us at
www.historypress.net